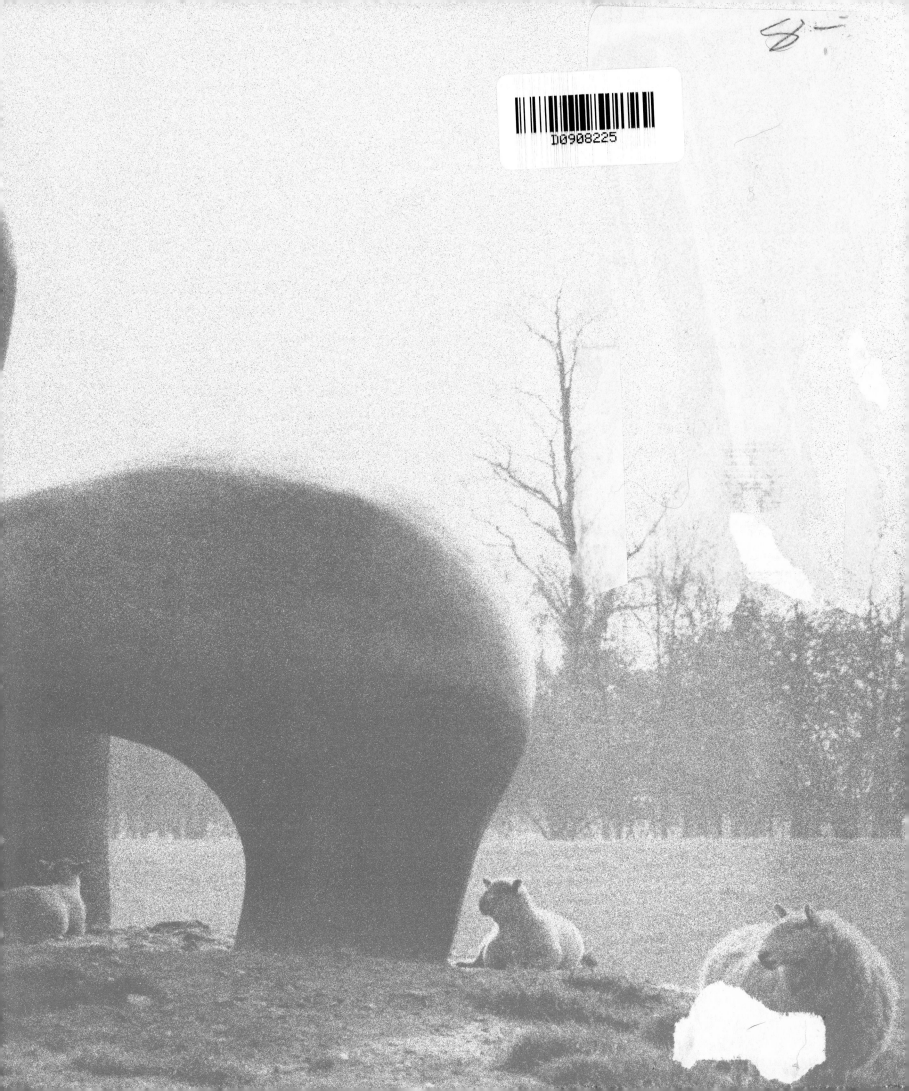

HENRY MOORE
SCULPTURES IN LANDSCAPE

HENRY MOORE
SCULPTURES IN LANDSCAPE

Photographs and foreword by
Geoffrey Shakerley

Text by
Stephen Spender

Introduction by
Henry Moore

CLARKSON N. POTTER, INC/PUBLISHERS
DISTRIBUTED BY CROWN PUBLISHERS, INC. NEW YORK

Library of Congress Cataloging in Publication Data.

ISBN 0-517-536765

First American edition published by Clarkson N. Potter, Inc.

Printed in Norway by Grøndahl & Søn Trykkeri

There were a few important sculptures which for
various reasons Geoffrey Shakerley was not able to
photograph. We are most grateful therefore to
Mr. Moore for the use of his photographs – plates
5, 45, 50, 71 and 72, and to Mr. Errol Jackson for his
– plate no. 53.

Design by Kai Øvre

FOREWORD

When I was asked to take the photographs for this book, it came as a complete surprise. I was with Johan Stenersen on the way to visit Henry Moore to discuss another photographic project, when he told me of this commission. It was the opportunity of a lifetime: to photograph Henry Moore sculptures in fifteen countries, to travel half way round the world, and to contribute to a book planned to celebrate the artist's 80th birthday.

However, the prospect was daunting. The time allocated for the photography, to allow publication on the actual birthday, was a maximum of six months which in practice became four months. And to keep costs within reasonable bounds, I could take no assistant abroad to help carry the heavy equipment needed. More serious still, I had little experience or knowledge of Henry Moore's work, and felt extremely diffident about attempting to interpret another man's creative genius.

Luckily, publication was postponed till later in the year, and once I had met Henry Moore, his warmth and encouragement did much to dispel my fears. Nevertheless he has strongly felt views on how sculpture, and his in particular, should be photographed, so everywhere I travelled I took his advice with me ringing in my ears.

When the final shot had been taken, I had travelled some twenty five thousand miles, using fourteen different airlines and many cars, trains and buses. I travelled much on foot as access to the sculptures was not always easy. I remember particularly in Holland taking the bus from Apeldoorn to the Kröller-Müller Museum and the conductor telling where to alight and pointing me in the right direction. As each corner approached, I thought the museum must appear. After two miles I came to an entrance gate where mercifully I was given a lift. The museum was a further four miles on.

What I have tried to achieve in this book is to show the compatability and sympathy which Henry Moore's work has with natural landscapes. I have therefore stood back as it were from the sculpture itself in order to give a feeling of the overall composition. I hope as a result that there may be those, coming new to his sculpture, whose appre-

5

ciation may grow with increased familiarity, as indeed mine has done. I was asked once whether having met Henry Moore helped me to a better understanding of his work. I feel that 'to understand' may be the wrong word – but I am sure that to meet the man must enhance one's appreciation of his work through his deep integrity, his vitality and his lovely humour.

Finally I want to express my deep gratitude to all those who have contributed so much and made this book possible.

Firstly to Johan Stenersen whose idea it was, and to his Managing Director Øivind Pedersen. They have given me more encouragement than I could have dared hope for, and allowed me a completely free rein in planning the photography.

To David Mitchinson, of the Henry Moore Foundation. His help over the ownership and location of the sculptures and at every other stage of the book has been totally invaluable. His patience has been remarkable, and he has that rare gift of making everybody feel that their particular project is the only one of importance at the time.

And to Mrs. Betty Tinsley, Mr. Moore's secretary whose kindness and help have made every visit to Mr. Moore's home, Hoglands, a memorable one.

To Felicity MacDonald, my perfect secretary, who planned every journey with meticulous accuracy – no small feat considering the vagaries of the weather and the uncertainty of the time required for each assignment. Without her untiring help I could never have completed the photography on time.

To all the owners of the sculptures, both private and institutional, whose co-operation was so gladly given. I received such hospitality and help whereever I went that I can only deduce that there is a direct relationship between the owning of a Henry Moore sculpture and the possessing of exceptional kindness.

And lastly to Mr. Moore himself. He is one of the very few great human beings I have been privileged to meet in my life. In his 80th year, I humble salute him and hope that I have begun to do his work justice.

I dedicate this book to my wife and family who tolerated my long absences from home with such patience and understanding

Geoffrey Shakerley

London
July 1978.

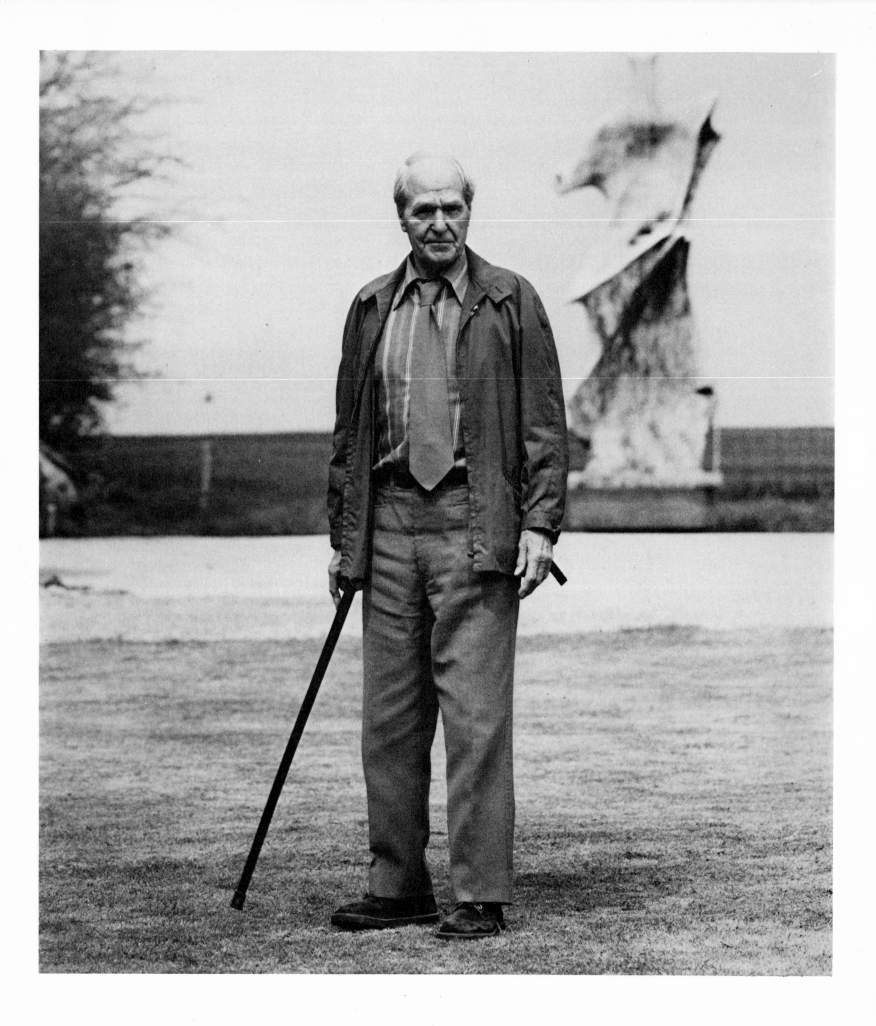

The sky is one of the things I like most about 'sculpture with nature'.
There is no background to sculpture better than the sky,
because you are contrasting solid form with its opposite space.
The sculpture then has no competition, no distraction from other solid
objects. If I wanted the most fool-proof background for a
sculpture, I would always choose the sky.

When I am asked by an architect to find or make a sculpture to go
with his building I am never very excited about it.
I know there will be problems. All architecture is geometric with
dominating horizontal and vertical lines, and these are
so insistent that if any assymetrical sculpture is put with it you will find
somewhere these distracting lines very evident in the background.
In fact the building's geometry is so insistent that to find
a position far enough away for the sculpture to have its own scale or
presence may be impossible.

When in 1963 I came to do the Reclining Figure for the Lincoln Center
in New York, I made my open-air studio at the bottom of the garden.
Up to that date it was the largest work I had undertaken
and I decided that I must make it in the open air. In our English
climate you cannot always work outside. Therefore I built this studio
(which structually is like a Meccano set, covered with
transparent plastic sheeting). The daylight is exactly the same as it is
out-of-doors, that is, coming from all directions but mainly
from the sky... I now use this studio for all my large sculptures which
are intended for out-of-doors, and therefore to be seen
in an outside light.

Henry Moore

Henry Moore with Large Standing Figure Knife Edge

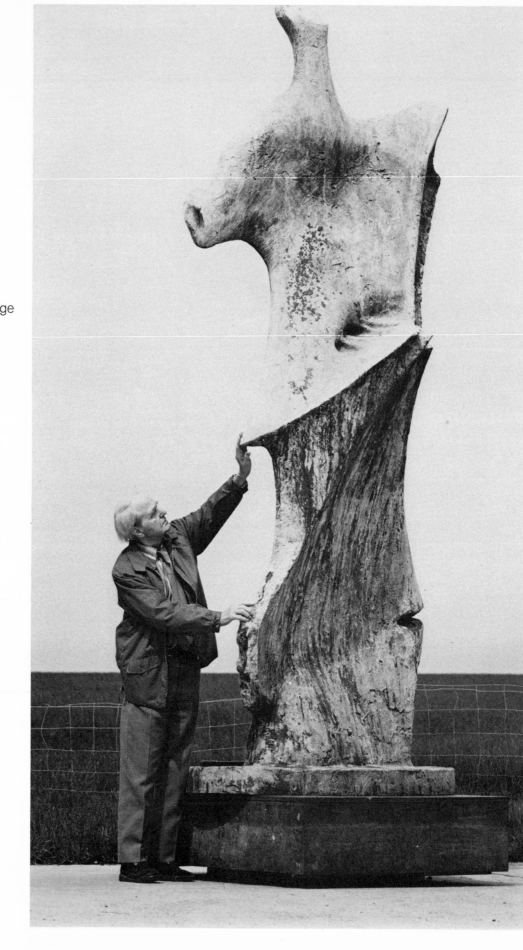

HENRY MOORE

BY STEPHEN SPENDER

The first occasion on which I ever saw a sculpture by Henry Moore was, I think, in the late twenties, when I was shown one by Michael Sadler, the Master of University College, where I was an undergraduate. I forget what it was, but I was struck by the form, the chiselled quality and the stoniness. After this I went to galleries looking for work by Henry Moore. His name acquired for me something of the aura of the artist identified with his vocation which I felt about those of poets like Rayner Maria Rilke and T. S. Eliot.

In coming years I often heard Henry Moore's work discussed among my friends, Geoffrey Grigson and Herbert Read in particular. People seemed sharply divided into those for whom Moore's work had some quality of integrity which seemed absolute to them and unlike anything else being done in sculpture in England, and those to whom it consisted of the famous holes he chiselled through stone or wood surfaces.

I got to know Henry in 1934, as the result of a piece of impertinence on my part. There was a literary magazine at that time (perhaps **The London Mercury**) which published each month portraits of living writers, done by their 'house' artist. The editor wrote asking me whether this artist, whose work I disliked, could come and do a drawing of me for the magazine. I wrote back saying that if a portrait of me were to appear in their pages I would like it to be done not by their man, but by Mr. Henry Moore. This was a gesture of the kind a young writer likes to make when he is twenty-five. I knew that Moore did not do portraits, so I expected nothing to happen. However, the editor wrote to him, and Henry, eleven years my senior, and perhaps intrigued by the request to draw a portrait, agreed to do it. I went to sit for him in his studio in Parkhill Road in Hampstead, and in this way became friends of him and his wife Irina. We have remained friends ever since. He made several drawings, for he had the idea that he might amalgamate drawings done from different angles in a single composite drawing of my head seen from several points of view. He abandoned this attempt, and one of the drawings was selected for publication.

All this seems so long ago, far longer than a mere five years before the outbreak of the war which was to change our lives so much. In those days, Henry's close neighbours in Parkhill Road were Ben Nicholson, the painter, Barbara Hepworth, the sculptor, to whom Ben was then married, and Herbert Read, the poet and critic. Ben Nicholson was painting circles and rectangles on boards on which he sometimes cut out these forms in bas relief. Barbara Hepworth was doing abstractions also. Ben and Barbara and Herbert used to meet in Henry's studio when I was there sometimes, and show each other recent work. How did Ben's rectangles and circles look in different lights? Did the slightly scooped-out circles sometimes seem to have movement, to rotate even?

Henry at this period seemed to feel that, partly out of loyalty to his friends and partly for reasons to do with his own developments, he ought to produce abstract sculpture. But, as he told me years afterwards, he was

never able to make a work which, in his own judgement, seemed completely abstract. His pieces always ended up by looking like something, often like a reclining figure.

It is worth recording that about five years ago, I asked Moore whether during his 'abstract' period he ever regretted his academic art school training which obliged him to draw from the nude: since it was the human figure which kept on intruding itself into his forms when he tried to make abstract sculpture. He answered, no, he had never regretted a training based on drawing from the model, and he felt a bit apprehensive today about the future development of young artists whose art training may have started off at the point of abstract art reached by artists who themselves had started off by drawing from the nude. He felt that this might trap them in non-representational art and limit the possibilities of their further development.

In his indebtedness to a tradition of art training centred on the study of the nude, Henry belongs to the generation of the great modernists of the early part of this century, Picasso, Matisse, Braque, Leger. One of the things that gives such tension to the work of these masters is that it seems to be moving in time in two directions at once, towards the remote – even prehistoric – past and towards the future: and, in geographical space, it shows an immense eclecticism of influence present in the work, André Malraux's **Musée Imaginaire.** At the same time in the greatest work of these masters, a unity which is entirely new is achieved from such variety in time and place. These artists are

the last geniuses of the Renaissance tradition. Their academic training – study of the human figure – was the meeting point between past and future which enabled them to travel backwards and forward in their own personal development as artists: sometimes appearing futuristic, sometimes as almost devout traditionalists making replicas of the past.

The aura of greatness radiates from them. They still believed in the Renaissance idea that the individual artist who is great is a titan who bears alone on his shoulders the burden of the whole world as he sees it and transforms it in his art. They wear like heroes' scars which are also medals the insults which were attached to their names when they were young and unknown. Thus it seems almost an essential part of the Moore legend that when he became a teacher at the Royal College of Art, the art critic of the **Morning Post** should have described the exhibition of his work held in a London gallery in 1931 as 'immoral' and that a Professor Garbe, who also taught at the college, should have taken the article to Sir William Rothenstein, then its head, and demanded Moore's dismissal – a request rejected by Sir William. In the study of Moore in which he recalls this incident, Herbert Read records that the 'garbage' on which the young artist had been feeding was Roger Fry's **Vision and Design** (1920) with a great essay on Negro sculpture, and Ezra Pound's book on the wonderful young sculptor who was killed in the first world war, **Gaudier-Brzeska** (first published in 1916 and read by Moore in 1922 or 1923), which is one of the most exciting defences of those artists who, whilst being pro-

Reclining Figure, 1939 photographed at Burcroft in Kent, Kingston

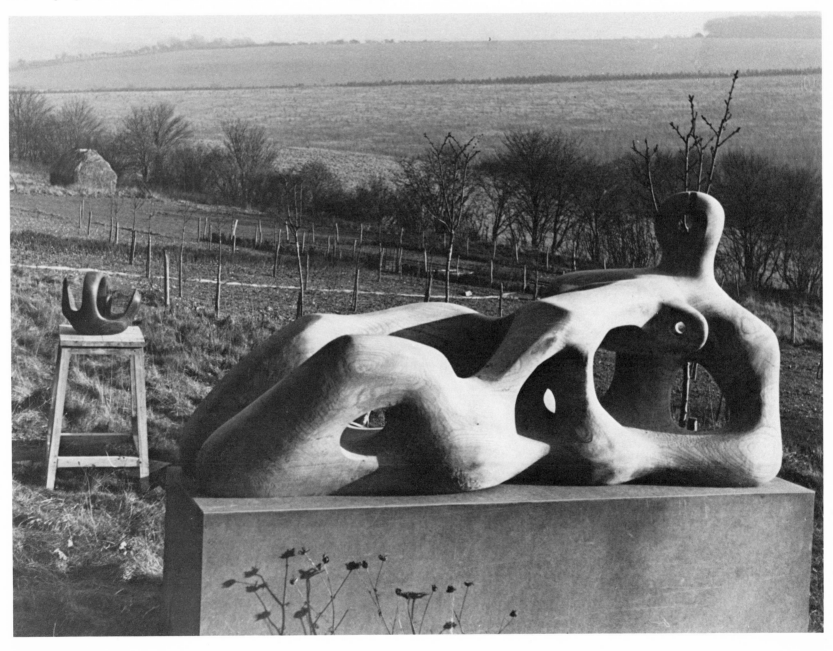

foundly rooted in the tradition, purposively 'make it new', written in that epoch.

When my friends and I discussed Moore's work in the early thirties, what struck us above all was the purism of a lover's fidelity to the material employed. Moore chiselled stone and carved wood and brought out the intrinsic texture of stone and wood. It was this reverence for the material as distinct from the subject matter which perhaps first drew Moore (and goes on drawing him intermittently) to abstraction. The subject of a work can be misleading in drawing attention to what the sculpture represents and away from the material used and realised. This was a period when it seemed very important to insist on the actual stuff of paint, or stone, or words, or sounds, of which an art object is made. At the same time as Moore was abandoning for a time the figurative subject in his work, the young poet Auden was writing poems to which he avoided giving titles, because the naming of the subject of a poem detracts from the verbal texture which makes the poetry.

However abstraction is itself a kind of representation – of a pattern or of some very unidentifiable shape called 'significant form', let us say. If you think 'this is an abstract piece of sculpture' you do not necessarily pay more attention to the material than if you think 'this is a mother and child'. You may see the material itself as abstraction.

Another reason why abstraction attracted Moore – or, rather, another two reasons – is that in a sculptor like Brancusi (and perhaps also in the work of Arp) the abstract artist was taking a stand 'for shape for its own sake, reducing a thing to just a simple egg',* and because simply to do this the sculptor must employ his utmost skill in mastering the material. 'You begin with a block and have to find the sculpture that's inside it. You have to overcome the resistance of the material by sheer determination and hard work.' Here 'overcoming the material' does not mean what Moore elsewhere refers to as 'being cruel to it'. The sculpture inside a Brancusi is surely the quintessence or epitome or ideal form of the material released.

The sculptor whom Henry Moore always admired as the greatest master of all, and with the greatest sense of vocation, Michelangelo, did not always avoid being cruel to his material. In fact, he sometimes makes it represent skin and drapery in a way which makes one forget that it is marble. Moore disliked what he called the 'leathery' texture of the skin in the figure of Night in the Medici Chapel, in Florence. Moore has had a life-long admiration – adoration even – of Michelangelo. Yet one suspects that sometimes in doing so he has felt himself struggling with a demon-angel.

His attitude to Michelangelo throws much light on Moore. It begins very early on indeed with one of the best known anecdotes of the Henry Moore legend, one so familiar that it must be an embarrassment for him by

* Quoted from The Documents of 20th Century Art: **Henry Moore on Sculpture,** edited by Philip James (The Viking Press, New York).

14

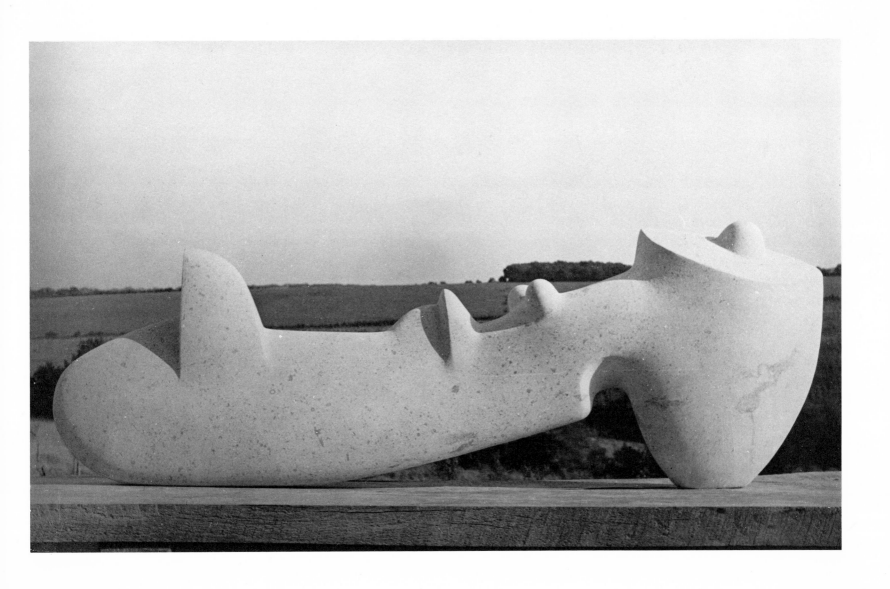

Reclining Figure, 1937, carving in Hopton Wood Stone

now to hear it repeated. When he was eleven years old and went to Sunday School he heard the Superintendent, in the course of a talk, describe a scene in which Michelangelo was carving the head of an old faun in a street outside his studio in Florence, when a passer-by remarked that a faun at that age wouldn't have all his teeth at which Michelangelo took up his chisel and knocked out two of the teeth. For Moore the message emerging from the anecdote was – 'Michelangelo – great sculptor'. From that moment on, he wanted to become a sculptor: more important than this, he wanted to be a **great** sculptor. Haunting him all his life has been the name and achievement of Michelangelo.

As we have seen, during much of his life, Moore has been conducting a lovers' quarrel with Michelangelo. Yet more important than this is the fact that before he had ever seen a work of Michelangelo, he had been shaken to the depths of his soul by the idea of his greatness – of greatness in sculpture, the greatness of the master.

It is a truism to say that for an artist to impress us with his greatness, he has to be great. It is not enough to be a megalomaniac like Benjamin Robert Haydon (though I doubt whether there is ever real greatness without a touch of megalomania). At the same time, given greatness in the art, the idea of greatness that it communicates can sometimes be considered apart from the work. It floats off, as it were. This is clearly true of Beethoven, Goethe, Balzac and a very few others. Not only is their work great but the idea of greatness of concept rings out from it like a bell. It can resound across the ages. One sees at once that Rodin in this respect responds to the greatness of conception of sculpture and the sculptor in Michelangelo. What Henry Moore is really telling us is that when as a child he heard the name of Michelangelo, he heard the call to be a great sculptor.

His attitude to Michelangelo throughout his own life shows his sense of the distinction between the work itself and the greatness of the man as artist. Henry Moore never revised his opinion that Michelangelo's achievement was the greatest of all, and yet as a young man, he found himself incurious about it. When he first went to Europe on a scholarship he avoided for many months seeing a work of Michelangelo. Nor did he visit the Rodin Museum in Paris. In his remarks about Michelangelo in the Documents of 20th Century Art book he shows his preference for the works which are generally regarded as unfinished – the sculptures of prisoners in the Accademia in Florence, naked figures which seem poised between being released by the sculptor's creating chisel and being locked within the stone. Moore prefers these to the completed 'Dying Prisoner' in the Louvre, a figure in which Michelangelo has used marble to convey drooping languor, a motive which Moore perhaps finds a bit repellent in marble. But the Michelangelo which moves him most is that sculpture on which Michelangelo was working up to a few days before his death, the Rondanini Pietà. Of this he says, 'I don't know of any other single work of art by anyone that is more poignant, more moving'. The legs of the Pietà are finished, and also disproportionately large,

Sculpture in the grounds at Hoglands

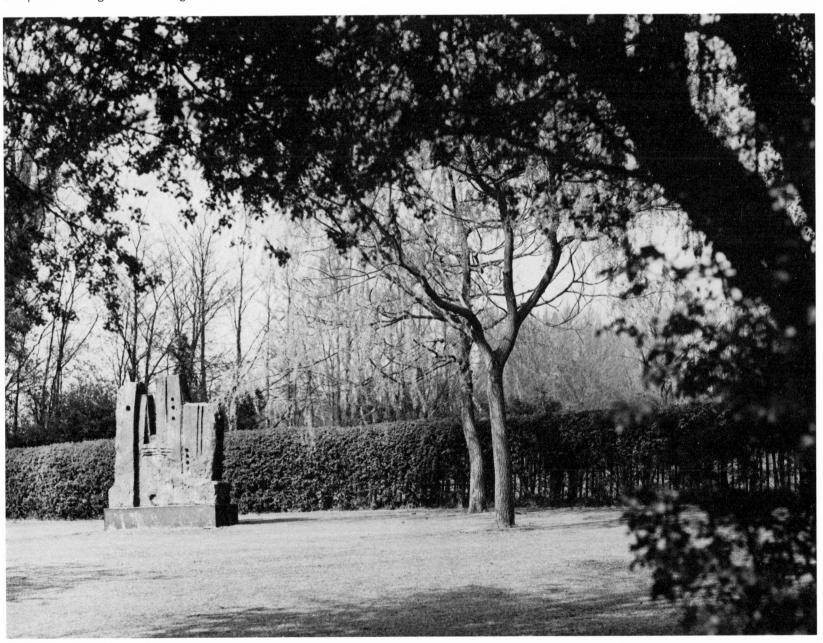

belonging to an earlier version from which Michelangelo must have knocked off the head. The top part of the sculpture – apart from an arm of the earlier version, left dangling down – is the very late, rough-hewn work of the aged sculptor, and is, as Moore points out, in an entirely different style from what he calls the 'tough, leathery, typical Michelangelo legs. The top part is Gothic and the lower part is sort of Renaissance'. For Moore, the style of the unfinished top part of the statue is influenced by the fact that Michelangelo felt the approach of death. The expression of the spiritual has become more important to him than the virtuosity and high finish of the high Renaissance style.

But perhaps the most illuminating of Moore's comments on Michelangelo is: 'This Pietà is by someone who knows the whole thing so well that he can use a chisel like someone else would use a pen'. To use a chisel or brush like a pen is a metaphor expressive of just what the Renaissance artists did – and the pen, one might say, while describing their sacred or profane subjects in marble or paint, also writes across the world the signature of the individual artist. A return to the Gothic style means abandonment of what Moore calls 'swagger' – which might be replaced by the word 'signature' – in exchange for the anonymous and objective realisation of humanity as an almost impersonal love and suffering.

Here is a note I made in 1965 when Henry Moore, accompanied by the art dealer Harry Fischer, visited America. One night I dined with him at Washington after the unveiling of a Moore bronze at the Kennedy Centre: –

I happened to remark that the work of Paul Klee interested me less today than it had when I was twenty-five. Moore agreed, and he thought the reason was this: that Klee was not really a major artist. This annoyed Fischer who said that Klee was, in his way, as good as Picasso. Moore said that Picasso was, nevertheless, a much greater painter than Klee, and this was what really mattered. He insisted on the importance of making comparative value judgements, of saying, for example – if one felt this to be the case – that Goya was a greater painter than Picasso, even though it might be impossible in our century for Picasso to have as central a position as Goya had in his time. Fischer said this showed that Henry had no sense of history. Henry said that had nothing to do with the matter. History should not be used as an excuse for avoiding comparisons, for saying, for example, that, given the historic circumstances, Watteau was as good as Rembrandt, and you were not entitled to compare them. It is evident that there is in Henry's mind a kind of hierarchy of artists, of whom among the greatest are Masaccio, Michelangelo, Rembrandt, Cézanne.

The Renaissance artists signed their work with their individuality in every chisel or brush stroke. Rodin also did this. Henry Moore shows the same ambiguous attitude towards Rodin as towards Michelangelo. He is stunned by the skill and virtuosity and the grand scale of the whole concept of the art but he is a bit repelled by the overmastery of the material, its too complete transfor-

mation into the subject matter, the signature of the artist and the subject of the work. He admires Rodin most when his works have an unfinished look: the 'unfinished' with Rodin being a deliberate attempt to give the material a chance to speak for itself. In his house at Much Hadham, Moore has a cast of the headless and armless version of Rodin's 'Walking Man', which, although in bronze, has rough, stony-looking passages about the shoulders and arms. Tension between the material and the stretched muscles of the nude body is dramatised in the work.

If one can imagine every great sculpture as a battleground in which a battle is fought between the material used and its transformation by the sculptor with his tools, one might say that the young Moore took the side of the material in such a conflict, the older man has come to admire victories over the material, but a bit doubtingly always. It took him a long time to get to appreciate the sculpture of Bernini. He began as a carver and an innate purism or puritanism in him for long made him distrust the melting down of the material into bronze. His first casts were two small leaden figures, lead retaining obstinately its quality of lead-ness.

The paradox of Moore is that he is one of the last great individualist artists, inheritor of a tradition of art based on drawing from the nude, which goes back to the Renaissance; while at the same time he shows a strong penchant towards the anonymous, impersonal and towards pre-Renaissance art and towards the Gothic. His sculpture expresses more of a moving sense of human-ity than of the egoistical-sublime of the self-assertive individualist genius. When he expresses a liking for the work of the octogenarian Michelangelo who reverts to a style which is Gothic, he is admiring the Michelangelo who sheds his name and invents an objective symbol for an almost universal human tenderness.

Although a 'Henry Moore' is one of the most immediately recognizable of inventions, if one didn't happen to know his name, one might be content to recognize the style of a great anonymous master, identified perhaps merely as 'the master of Much Hadham'. His works also are sometimes provided with titles so perfunctory ('Locking Piece', 'Upright Motive') – or at other times so obvious ('Falling Warrior', 'Mother and Child') that they seem to disclaim having any title at all. At any rate, one readily decides for oneself that the title very often is no indication of the real subject. Considering the ecleticism of so much of the work – with African, Mexican, Greek-cycladic, Egyptian and many other influences – and the insistence on the integrity of the material, one might conclude that these sculptures have no subject except, in each case, what the work itself reveals – a material, an influence, brought within the unity of a consummate style by a great master.

However, there are many indications that Moore does have a subject matter, deeply buried in early experiences and his subconscious, which is unique to him. That this is so is demonstrable even in those works in which he seems most concerned with simply inventing a form which realises the intrinsic qualities of the ma-

terial. Moore himself provides evidence for at least one striking example of this.

He recalls an early experience which he thinks one of several influencing him to become a sculptor. When he was ten or eleven years old, his father took him to see a rock formation near Leeds called Adel Rock – a haunt of tourists. The shape of the leg end of one his earliest two piece 'Reclining Figures' recalls the shape of this rock. But it does more than this. It also recalls that of Seurat's painting of rocks that stand out from the coast, near Etretat, which was once in the collection of Moore's close friend, and patron, Kenneth Clark. Moore, in a cassette tape recorded interview which he has sent me recently comments: 'So perhaps you look at something and the shape registers and you probably use it; or if that shape comes up again, you like it because it has an emotional meaning for you, even though the memory may not consciously make the connection',

So there is a memory of a past impression released by a present impression analogous to it. One might add that, to the memory of an emotion about rock which is a fusion of the feelings about Adel Rock and the Seurat, there is the emotion which the sculptor has about the material with which he is actually working and which he shapes not by imitating either Adel Rock or the Seurat, but by creating a third thing, the artefact, by a process of co-operating with the material which he can only describe as instinctive. The basic subject of Moore's greatest works is past memories of shapes seen evoked by present experiences which bear an unaccountable

similarity to them. The process is very much that which Proust describes in **Time Regained.**

One of Moore's earliest experiences of sculpture was that of going to Stonehenge when he was a student and of seeing it first by moonlight, and then by day for several days. He has gone back there many times subsequently, for, as he tells me: 'Stonehenge is as much sculpture as it is architecture, being man-made big blocks of stone which have been shaped roughly, with an axe probably'.

Stonehenge also taught him early on the significance of size in sculpture placed outdoors. The great mysterious circles of stones suggested sculpture which you could go inside, which Moore was to make nearly half a century later: 'The Arch', reclining figures of three or four pieces which surround you, and the project for a maze of stone forms which you can enter and of which the sky, changing every hour of the day, and, at night encrusted with stars, and with perhaps the moon, would be the roof. In India, as Henry Moore probably knows, Indians will take you to see temples in the middle of the night. Also in Greece, I have visited Delphi by moonlight and had the mysterious sensation that temples and statues belong as much to a map of the stars, as to their positioning on the earth.

Moore has then a rich and varied subject matter whose sources go back to an almost Wordsworthian contact with his natural surroundings when he was a child. For Wordsworth, of course, his earliest experiences were of

untrammelled nature – an Edenic setting which separated him from the industrial landscape – and of the image of the mother which he identified so completely with nature that in **The Prelude** the child seated on his mother's lap – very much, one supposes, in the attitude of a Moore Mother and Child – feels himself one with a mountainous river-flowing landscape. Wordsworth was never able to reconcile the industrial scene in the England of his time with that of untouched nature. One might suggest that Henry Moore, who in his sculpture is so often preoccupied with splitting form and then making a fusion of the two parts, divided by a fissure, within a whole which is the unity of the sculpture, found in his own childhood the double experience of both nature and industrial landscape which enabled him in his art to solve the Wordsworthian dilemma of the separation of nature from industrial society.

Moore passed his childhood not in the untouched countryside of Wordsworth's Lake District but in a small industrial town – Castleford – in the mining country of Yorkshire. He was the youngest son of a large family. His father was a coal miner, a man who had done much to educate himself. He had read all of Shakespeare. He was also politically conscious, an active trades unionist. His mother was an impressive woman, a strong, kind and intelligent personality whose portrait by Moore's student friend Raymond Coxon, which hangs in the Moore's sitting room at Much Hadham, gives an impression of kindness and firmness. Moore confesses to having a 'mother obsession' and clearly memories of his mother, very physical often, influence his sculpture.

Like the neighbourhood of D. H. Lawrence's Nottingham, Moore's Castleford is not far from some of the most beautiful country in England. Moore experienced in his childhood the backstreets of the industrial town and the beautiful countryside, and, since he loved both, both are fused within his work. Other noted sculptors, artists and writers have come from this section of Northern England. Moore himself notes four other sculptors – Barbara Hepworth, Kenneth Armitage, Ralph Brown and L. Thornton – who have come from Yorkshire. Perhaps the most sensitive and deeply felt book about Moore is that by Herbert Read, who also came from here. Lastly, W. H. Auden explored the Yorkshire landscape when he was a child, the moors and worked-out pits where there was rusted old-style industrial machinery, which plays a part in his early poetry. In one of his most celebrated poems, 'In Praise of a Limestone', he celebrates a landscape which reminds him of sculpture, in lines which might be printed side by side a sculpture or drawing by Moore (Moore did do a book with drawings and lithographs for a selection of poems by Auden).

If it form the one landscape which we, the inconstant ones
 Are constantly homesick for, this is chiefly
Because it dissolves in water. Mark these rounded slopes
 With their surface fragrance of thyme, and, beneath,
A secret system of caves and conduits, hear the springs
 That spurt out everywhere with a chuckle,
Each filling a private pool for its fish and carving
 Its own little ravine whose cliffs entertain
The butterfly and the lizard.

Herbert Read describes the games which Henry played with other children in 'a maze-like labyrinth' of lanes close to the little house, one of a terrace, in Castleford. There was a game called 'tip-cat' played with sticks called 'piggies' which had to be pointed by whittling with a pen-knife. Herbert Read suggests that carving 'piggies' may have been Henry's earliest sculptural experience. One which Moore himself notes, and which is less fanciful, is that he used to rub his mother's back when she had pain from rheumatism in it. 'Not just her shoulder,' he tells me, 'but her whole back down from the shoulder blades with the skin close to the bone, to the fleshy lower parts. I had a strong sense of contrast between bone and flesh. I was seven or eight at the time.' More than half a century later, working on the figure of a pregnant woman, he found himself all the time thinking of rubbing his mother's back. In their front parlour, his mother also scrubbed the back of his father, very much in the manner described by D. H. Lawrence in **Sons and Lovers** of the wife scrubbing her miner-husband's back.

The backs of figures in Henry Moore's sculpture have often something tender and moving about them – a sacred homeliness. They are much worked on, scratched and lined and scarred, like the surface of a much scrubbed kitchen table. They can be gently and beautifully curved, suggesting both dignity and tenderness, as in the back of the King, in the 'King and Queen'. One of Moore's objections to sculpture in architecture is that so often it conceals the back of the sculpture. The only sculpture of which there is no trace of influence in his work is the Baroque. This may be because Baroque sculpture is so much made to be looked at from the front – gesticulating figures with actors' or singers' gestures and faces – or screens set against walls, and having no backs to them.

Henry Moore's subjects arise from memories, often unconscious. These connect sometimes with material that is atavistic. Moore has told me that about twenty yards from his home, just along the street, there was a butcher's shop, behind which there was a large room or shed, with door open onto the street, in which the butcher slaughtered cattle once every week. 'We small boys, of the ages of four, five, six and seven, would stand there watching a bull led in by a rope attached to a ring through its nose, by two men who ran the end of this rope through another ring which was fixed in the wall. Using this as a pulley, they pulled the bull up against the wall. One of the men then struck the bull a severe blow with a stick at the end of which there was a long spike, so that this made a hole in the bull's skull. He then thrust another stick through the hole and stirred up the bull's brains.' The boys stood watching. A man who killed bulls with despatch acquired a local reputation for doing so.

Clearly this experience of the slaughterings had a great influence – sometimes obscure sometimes self-evident – on Moore's work. Cleaving a skull, human or animal (and it is interesting that Moore in describing the scene to me linked it up with people viewing the public hangings which took place at Aldgate in the early 19th Century)

is a sculptural act – perhaps the most primitive sculpture of all. The connection of this with several animal heads and animal forms (notably the 'Animal Head' of 1956) is obvious, but one feels it imminent in many other pieces.

I have mentioned a Nottinghamshire miner's son – D. H. Lawrence – as being a great modern artist emerging from a background very similar to Moore's. To press the comparison a little throws further light on Moore's work. Both Lawrence and Moore had 'mother-fixations', but whereas Moore's mother seems to have been eminently self-controlled, Lawrence's had a passionate almost hysterical fixation on this, her youngest son, and projected into his consciousness all her frustrated ambitions. Lawrence's father, unlike Moore's, was much less educated than his mother, and became the object of a hatred perhaps not so much Oedipal as transferred onto Lawrence by the will of his mother (but Lawrence was also capable of sharing his father's resentment for his mother). Lawrence and Moore were both conscious of their working class origins, though these produced in Lawrence intense class consciousness and an inability to fit into any social class, whereas Moore never seems to have shown any social embarrassment, hatred or resentment, and to have fitted into every society simply as a member of the human race, with his added aura of being a great artist. Kenneth Clark once remarked to me that if a race inhabiting a distant planet were discovered and it was necessary to send to them a representative of humanity, no better ambassador could be chosen than Henry Moore.

Lawrence is the literary artist of the released unconscious. Beyond the pursuit of sexual union by characters in his novels is that of immersion in dark forces of unconsciousness, a loss of identity and individuality in a beyondness of life forces. Lawrence goes from light down into the darkness of the unconscious, Moore comes up from the unconscious into the light. The difference between the two corresponds almost exactly to Nietzsche's distinction, made in **The Birth of Tragedy,** between the Dionysian and the Apollonian. The characteristic of the Dionysian is to enter into a state of ecstasy in which 'the subjective vanishes into complete self-forgetfulness'. This is the aim of characters in Lawrence's novels and they achieve this condition through sex. The characteristic of the Apollonian Nietzsche calls 'the cheerful acquiescence in the dream-like experience': –

that measured limitation, that freedom from the wilder emotions, that philosophical calmness of the sculptor-god. His eye must be 'sun-like', according to his origin; even when it is angry and looks displeased, the sacredness of his beauteous appearance is still there.

The Apollonian does not repudiate or reject the phenomenon of the Dionysian 'drunkenness'. He shapes them, illuminates them, brings them up into the light of consciousness. He is aware when he sees the Bacchanalian rites that all this is true: 'that, like unto a veil, his Apollonian consciousness only hid this from view'.

In The Documents of 20th Century Art, an interviewer

asks Henry Moore the question, what is his reaction to the erotic side in Rodin's work ('he can revel in sensuality in a quite uninhibited way') Henry Moore's answer is worth quoting in full:

It is certainly very important for Rodin, though it doesn't excite of interest me very much, perhaps because one knows the human figure so well. But for Rodin I think that this erotic excitement was part of his rapport with the human figure. And he was unlike Cézanne, who had his erotic side but who repressed it. This doesn't make Cézanne less of a physical artist, and I don't think you ever need this obvious erotic element for a person to understand the human figure. You don't get it in Rembrandt, and I would say that Rembrandt understands the human figure and the human character and the whole of its dignity and everything else.

That, surely, is a reply from the mouth of the Apollonian artist.

The Apollonian artist brings the shapes of the unconscious up from darkness into the light, encloses them within a surface which is like a shining veil. Certain sculpture of Moore – 'The Archer' – for example seem in contact with the light-bearing side of Greek art in exactly this manner.

The Moore's house at Much Hadham is called Hoglands. It has been considerably extended by Henry and Irina Moore, but the original house goes back to 1600. Henry thinks that it may have belonged at some time to farmers who did their own killing of live-stock, or there may have been a butcher's shop here. At any rate, digging in the garden, they constantly find bones, old ones, with serrated edges where they have been sawn off. Moore told me that on first discovering numbers of these, he became very excited and that their forms inspired him to a whole series of sculptures. One is tempted to think that the reason for its stimulating him to such activity may have been that the later discovery of the bones released in his mind dark memories of the slaughterings in the butchery twenty yards from his home when he was a child.

One of the works inspired by a dug-up piece of bone, three inches in length, was the fourteen foot high 'Standing Figure: Knife-Edge'. The original plaster maquette for this was structured upon a piece of the bone that had been dug up in the field, just as the original maquette for the 'Warrior with Shield' is structured on a piece of flint which is embedded in the thigh. Moore told me that when making the Standing Knife-Edge figure he had in mind the famous Greek figure of Victory from Samothrace, in the Louvre, its winged, floating uplifted quality.

Metaphorically, and also literally, one may speak of Henry Moore, as having always worked in two studios, one indoors and one outdoors. As a student at art school he worked indoors, drawing from the model. But during the vacations he would stay with one or other of two sisters, both of whom had cottages in the country – one in Norfolk, the other in Kent – and work in the garden from small blocks of stone. A lot of his sculpture

24

of the early twenties was done in this way, and he feels that figures he carved then were influenced by his natural surroundings. He was delighted when while he was in the open air doing a carving of a figure with raised knees, a small girl came up to him, looked at the sculpture and said: 'Oh it's a church!' and the critic H. R. Wilenski remarked monosyllabically of a reclining figure with upward-pointing breasts, carved from green Hornton stone: 'Mountains'. Moore recalls that when he went on this honeymoon he took with him, in a case, a lump of alabaster to work on.

After their marriage, the Moores bought a cottage of their own, near Canterbury, and here also he worked outdoors. From his studio, the garden, he could see the surrounding landscape, and he felt, and feels, that the scale of things is bigger outside. There is a largeness which the outside imposes on a work. For example, a statue of Walter Raleigh, in London, at Westminster, looks diminutive, because it is life size. It looks as if Raleigh were about four foot six inches high, Moore says.

The contrast between the scale of things inside and outside seems demonstrable at the house in Much Hadham in Hertfordshire where the Moores have lived ever since they bought it at the time of the near-destruction of the Hampstead studio by the bombing during the war. Much added to since then, and with surrounding fields which Moore has acquired and uses as sites for his sculpture (though sheep moving among the sculpture nibble at the grass) the main living room just

Henry Moore photographing in the studio

25

out into the garden, somewhat like the prow of a ship. This large extremely pleasant room, containing objects which Moore has collected – a Degas pastel of a nude, some Seurat drawings, a landscape of rocks by Courbet, an early Italian alabaster figure drawing a curtain, a 3rd century figure – perhaps Persian – of a lynx, and many small pieces by Moore himself – shows the indoors side of Moore's interest and work, the scale of domesticity which is very real to him. There is also, near the house, a small studio in which he works on maquettes, and which contains bones, flints, and other objects, shapes with which he surrounds himself.

The large living room juts, as I wrote above, into the garden with its trees, a wall, a hedge, and beyond the hedge a path which leads to what Moore refers to as the 'outside studio' which is, indeed, about as outside as you can get, a kind of hangar for containing very large sculptures, and structured on metal stays, covered over with sheets of plastic or cellophane. It is here that Moore, with his assistants, works at his big projects. And beyond this and a neighbouring more closed-in studio there are the fields with statues placed in them at considerable distances from each other. There are also statues in the garden on the walk down to the outside studio. At various times I have seen in this lower garden or in the fields the 'Draped Seated Woman', the 'Arch', one or two 'Upright Motives', 'Locking Piece', the 'Archer', etc.

Since the war Moore has grown increasingly interested in displaying sculpture outdoors. The stimulus for this may have been provided by Tony Keswick's placing of some of his greatest sculptures ('Standing Figure', 'King and Queen', 'Two Piece Reclining Figure' and 'Upright Motive 1 Glenkiln Cross') on his estate in Dumfriesshire, Scotland. My wife and I have been to see these, though on a day of pouring rain, and I can well understand how even to the sculptor himself, they must have seemed a revelation. Henry Moore says on the tape he sent me: 'How important to me that Tony Keswick bought that 'Standing Figure' and placed it there without telling me until he invited me to see it. The setting is marvellous and so is that of the King and Queen and the Cross. All are placed perfectly. Seeing them has convinced me that sculpture – at any rate, my sculpture – is seen best in this way and not in a museum'. He was specially impressed by seeing his sculpture placed upon, and among, hills. He comments that if Stonehenge had been in a hollow people would not have approached it seeing the statues against the skyline.

Another point that struck him about seeing his work in Dumfriesshire is that it took at least ten minutes to walk from one sculpture to another; and he felt that this little bit of extra effort enhanced one's appreciation of the work. 'At Delphi you have to work from one temple to another. But the Greek landscape,' Moore goes on, 'is a terrific affair. The Parthenon is really sculpture in landscape. Greece! I think their landscape is their body. They come upon the sea just round the corner everywhere. I think they have a sense of their landscape like of their own bodies. You don't have to be told there that landscape is important. All their siting is marvellous ... But in

The open air studio in the grounds of Hoglands

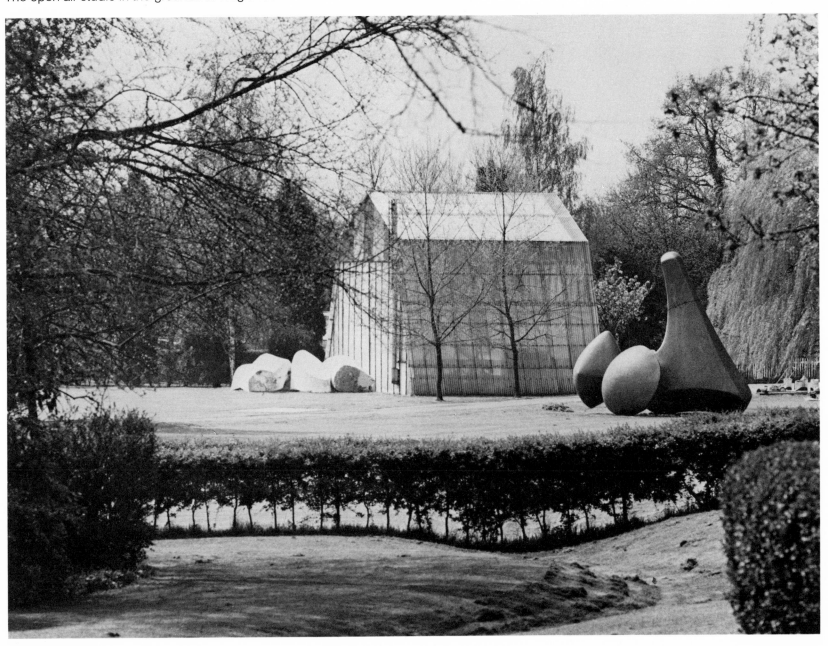

Landscape at Hoglands, Much Hadham, Hertfordshire

England churches are sited on high spots ... or on big long flat plains which you can see from many miles away. Like Chartres. The formation of landscape can be thought of as sculpture. Landscape is really bas relief. The earth itself is the three-dimensional sculpture: the hills on it just little pimples ...'

Moore is as excited about sculpture in landscape as he is discouraged by it in an architectural setting. He says that he is never very pleased at the prospect of doing something in an architectural setting. Architecture is horizontal and vertical. It is geometric, and this creates problems for the sculptor, if he puts sculpture in front of it. The problem is to find a blank enough space so that the insistent vertical and horizontal lines of architecture do not insist on their own rhythm counter to that of the sculpture, which has to be related to the architecture. He recollected that when he was commissioned to make a sculpture for the Unesco building in Paris, he spent six months trying to produce a piece which had its own background which would prevent it being interrupted by the architecture. But to do this – in which he was not successful – would have cut out the back of the sculpture. Sculpture has to be seen from a hundred points of view – bird's eye, worm's eye. That's one thing sculpture does that painting doesn't do, Moore says. A painting can only be looked at from the front (unless it's that skull in the Holbein painting of two ambassadors, which can only be seen to be a skull if looked at sideways. But that's just a stunt.).

'All the sculptures I've done that had to do with architecture have been a problem. Unless there are so many buildings there already that it doesn't matter – nothing can be done about it ... Whereas nature has none of these disadvantages. Nature is asymmetrical and its scale is a human one, even when there are mountains. But architecture can be so brutally big that the humanity drops out of it.'

I am quoting from the remarks that Henry Moore sent to me on tape, in the course of a conversation in which I did not participate. If I had been there, it would have been to the point to tell him that his arguments about sculpture and modern architecture confirm the thesis of a famous German novel, **The Sleepwalkers,** by Hermann Broch, which was published just after the first world war. The narrative of this novel which describes the mysterious and chaotic lives of characters in post-war Germany, is interrupted by a thesis argued at considerable length which is that the fragmentation of modern civilization is evidenced by the fact that it is impossible to place sculpture in the setting of modern architecture. The reason why this is so, is because modern architecture itself projects the totally inorganic state of modern society, it being of all the arts the one that represents the contemporary human condition at any given historic time. Medieval architecture reflected man's belief in his religion, which was the core of that society, and therefore the cathedral was organic, the relationship of sculpture to it that of the flower to the plant, the human to the divine.

It might seem that Moore's experiences in trying to relate

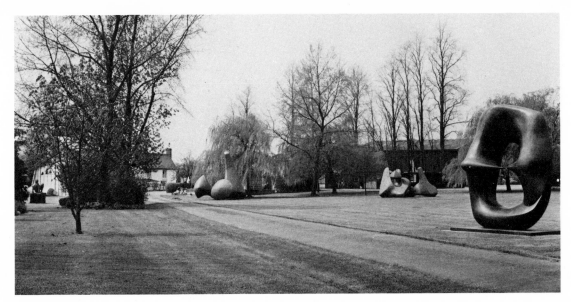

General view of the garden at Hoglands

Looking towards the rear of Hoglands from the garden

sculpture to modern architecture are tests which prove Hermann Broch's thesis. He discovers that the geometry of horizontal and vertical box-like and criss-crossed modern buildings threatens any sculpture put in front of it. 'If it's a figure you'll find its head cut off, or that the body is split down the middle. It's no good putting an upright figure against a skyscraper. Sculpture is like a human being. Architecture is inhuman.' 'A sculpture should be good anywhere, provided it isn't put in a situation which impedes it, like a person who may look very well at a cocktail party – but very badly at home.'

Sculpture always looks good against 'the jumble of nature'. 'But the really fool-proof background is the sky. In the city of Edinburgh the statues along the unbuilt-up side of Princes Street always look well – although they are by no means good statues – because they are seen against the sky. And then there is Nelson's column! And Trajan's column!'

'And out of doors the light is always changing, with the hour of the day and with the seasons, and at night. Moonlight magnifies.'

Moore remembers his first visit to Genoa at night and walking through the streets, admiring the buildings by moonlight. But next day, of course, many of them looked terrible. Some were slums. A lot of things admired by moonlight, sunlight shows to be awful.

'Think of bronzes in rain, and of trees themselves sculpture which sheds leaves and reveals the bare skeletons of trunk and branches. But never so geometric as to compete with sculpture, only providing contrasts to it.'

Moore likes the idea of sculpture standing in water, and this he has achieved with the great Reclining Figure at the Lincoln Center in New York.

He is glad that he was responsible for arranging the exhibition of sculpture at Battersea Park. 'Being responsible for it, of course I gave my sculpture the best place.'

In his mind's eye, Moore sees, I think, his sculpture as driven out of the cities through being unnoticeable to the inhabitants and scrawled out by the architecture – and add to this, the traffic – and retreating to take up positions in the countryside. The museums are right for what I call his smaller 'domesticated' pieces but too small for the monumental ones. These claim landscapes, and the effort of seeing them should be slightly athletic, a ten minute walk between piece and piece, not that peculiar fatigue called 'museum feet'.

Moore is staking out a claim not only for bits of countryside but for the future. One wonders how these statues will look in fifty or a hundred years time, on hills, on plains, in woodlands, among vegetation, against the fool-proof sky, in rain, against the sea, in the changing light, changing in appearance every minute. If they are not vandalized by the orgiastic Dionysians of our time – the age of terrorists and druggists – or destroyed in nuclear war – they may seem survivals from a great age of art at once individualist and of the liberated uncon-

Sculptures in the grounds at Hoglands

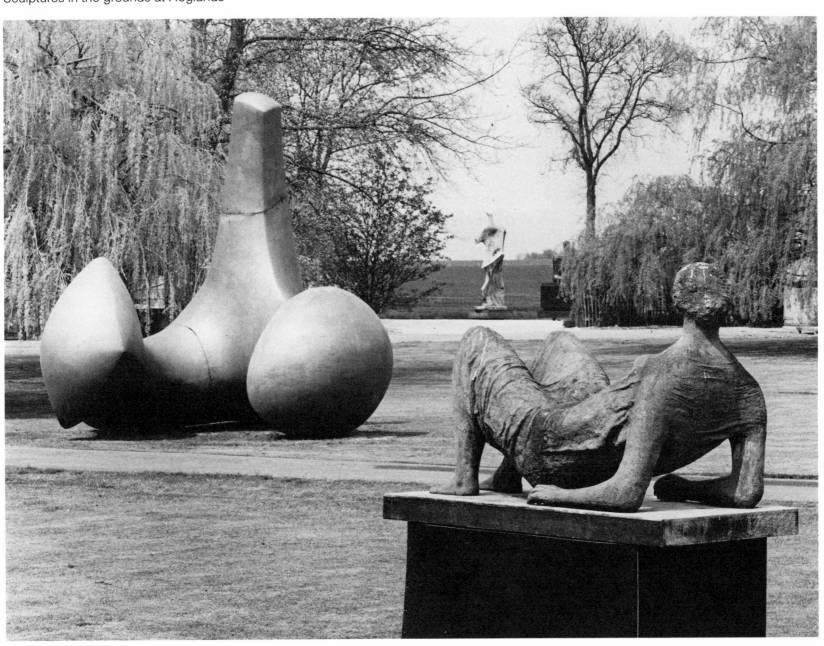

scious of the beginning of the twentieth century. Some may become popular symbols accepted almost as stereotypes, as has happened with the sunflowers of Van Gogh. At any rate they have the look of survival. One notes here the strange abstracted faces of Henry Moore figures – looking into the future. They are not so much abstract as abstracted; or using the term 'abstract' in a Shakespearean way, 'brief abstract and chronicle of the time'.

The faces of the mother in the groups of Mother and Child are abstracts of sacred motherhood. The face of the 'Draped Seated Woman' drained or purified of expression, yet seems proudly gazing into the future. Other faces seem abstracts of the modern human condition, for instance that of the 'Seated Warrior', with a hole, or holes drilled through eye-sockets which are seen in profile and between which there is a deep cleft which an axe might have made through the skull. One cannot look at the 'Seated Warrior's head without thinking that one might thread a string through the head, eyes and this is reminiscent of the bull with a ring in its nose through which a rope is threaded, brought by two men to the slaughter house. Moore always sees affinity between the animal in man and in beasts.

The abstractness of the heads of the seated 'King and Queen' is that of gods of the Underworld – D. H. Lawrence might have seen them like that. The twin heads of the armatured, skeletal, 'Standing Figure' on Tony Keswick's estate are like antennae, giving the whole figure the look of a standing alerted insect, an erect Praying Mantis, or perhaps of a spanner stood upright. Then there are heads which combine strangely the animal and human, faces from dreams, the unconscious, like those dream symbols which Auden describes Freud (another Apollonian) of bringing up from darkness into 'the bright circle of his recognition'.

Herbert Read looking at a Henry Moore bronze we have at home called enigmatically 'Three-Quarter Figure' said to me, 'Henry Moore is the one real surrealist'. By this he meant not that Moore had a leading position – or any position at all – in the surrealist confraternity, but that Moore is the one artist of our time who has unquestioningly and unhesitatingly always drawn on unconscious sources of memory for his inspiration. This is true, I think. He has done so without fuss, and without psychoanalysis. He has always rejected invitations to look too deeply into himself and the processes of his own imagination. Of a book that he was sent by a Jungian psychoanalyst writer called (he thinks) **The Archetypal World of Henry Moore,** he commented: 'He sent me a copy which he asked me to read, but after the first chapter I thought I'd better stop because it explained too much about what my motives were and what things were about. I thought it might stop me from ticking over if I went on and knew it all ... If I was psychoanalysed I might stop being a sculptor'.

Sculptures in the grounds at Hoglands

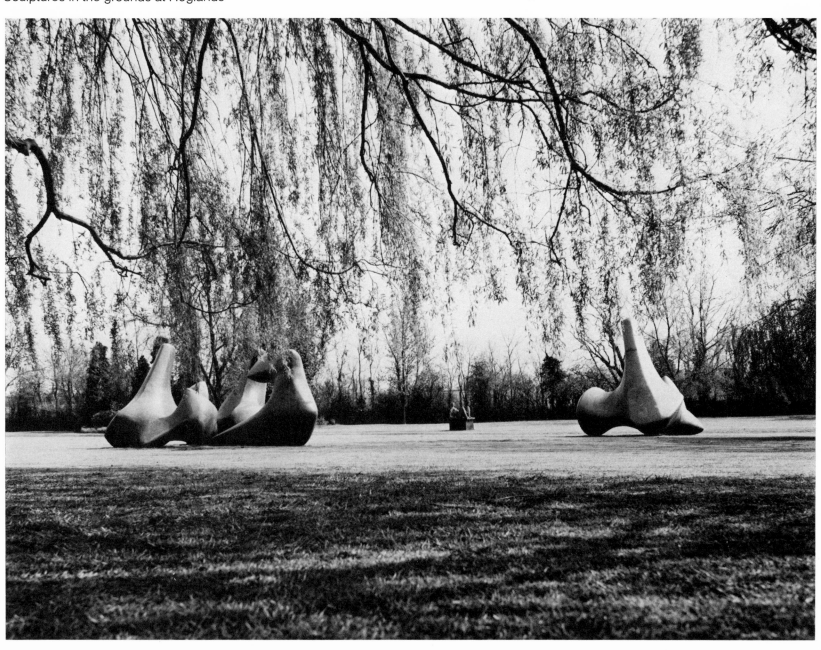

These are the observations of a man who does not think of his subconscious as a repository of repressions and inhibitions either to be cured or even sublimated. On the contrary, it is like a well at the bottom of the garden which, in his case, happens to connect with a particularly fecund, ever-renewing spring. Nothing would surprise him less than to be told by Jungians that this well connects with waters underlying all dreams, that there is a collective unconscious, and that his images are among its archetypes. One feels that Henry Moore has always realised this. I have never heard him say anything to suggest that he had given any serious thought to the proposition that other people might find the symbols in his sculpture 'peculiar'. On the contrary, I think that because they constitute an act of recognition on his part of unconscious memories within him, he thinks everyone should recognize them.

From this one might deduce that Henry Moore should be in the best sense of that term – a popular artist. In giving immensely vaulable collections of his work to the nation, he himself perhaps feels that he is an artist of the people. And if the people were educated in recognizing the infinitely rich resources of the imagination accessible to them in their own lives, this would doubtless be the case. The French surrealists once wrote an open letter to Stalin declaring that they were the true communists because the life of the subconscious was the real proletarian element common to the whole society. Coming from André Breton and his friends, this did not mean very much, but it pointed to a truth of which the work of Moore should be an example. But a characteristic of the working class is that they do not think they have a subconscious. A London policeman rebuked the photographer David Finn for wishing to photograph the 'Knife-Edge: Two Piece' near the House of Lords in London with the words: 'You have to admit it's just a pile of junk'. Yet one should not be too discouraged by such a reaction. It is at least positive. It is not one of utter indifference to the whole phenomenon of 'modern art' which one finds among buyers at shopping centres in America. But in all such cases one has to remember the parable of the sower: some seed falls on stony ground, but some on good soil and takes root.

Stephen Spender

36

Henry Moore in the grounds of his house, Hoglands 1977

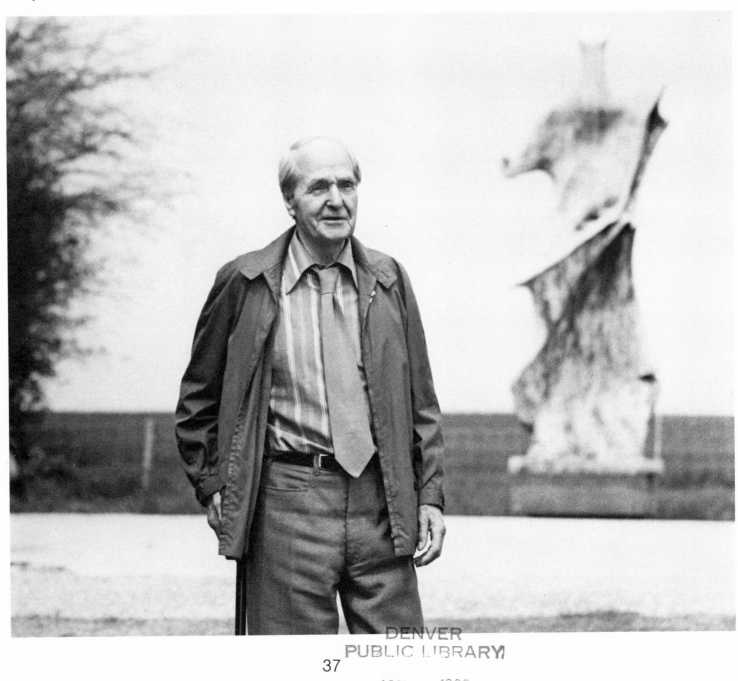

Three Standing Figures in progress at Hoglands 1947

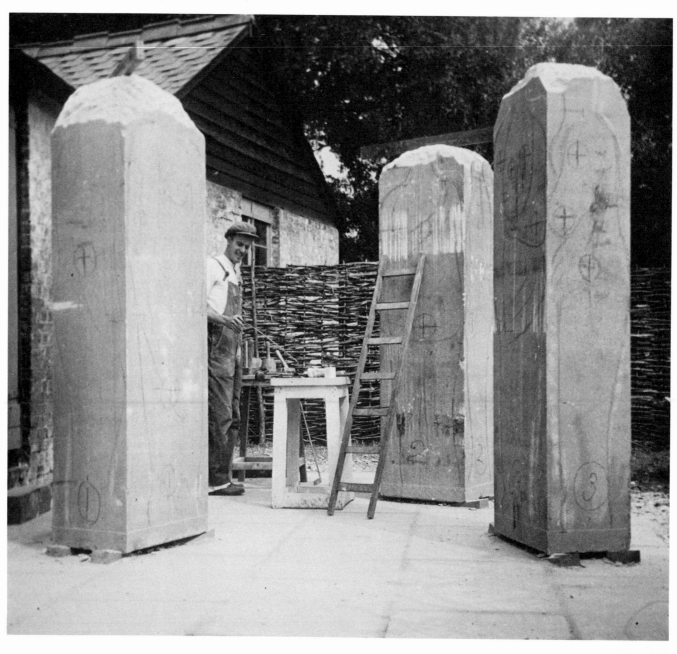

Three Standing Figures in progress at Hoglands 1947

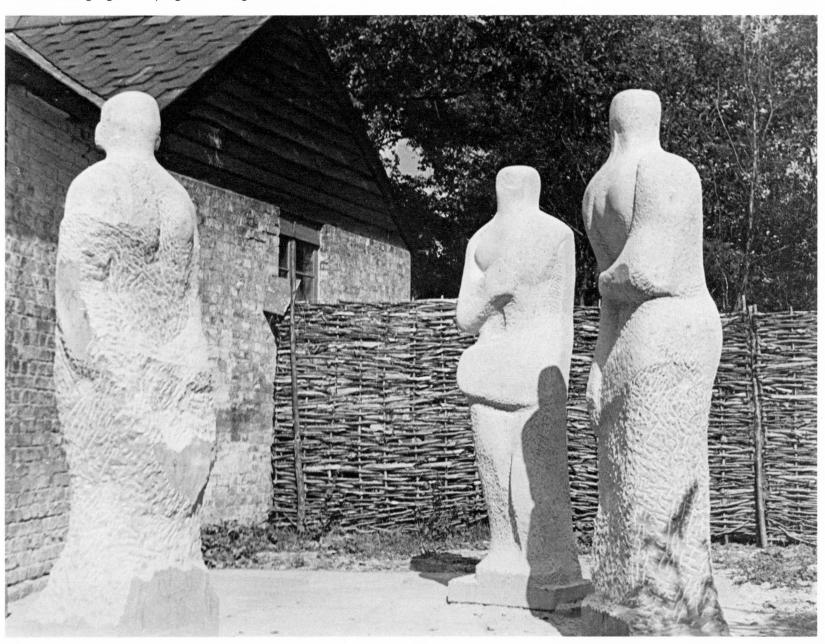

PLATES

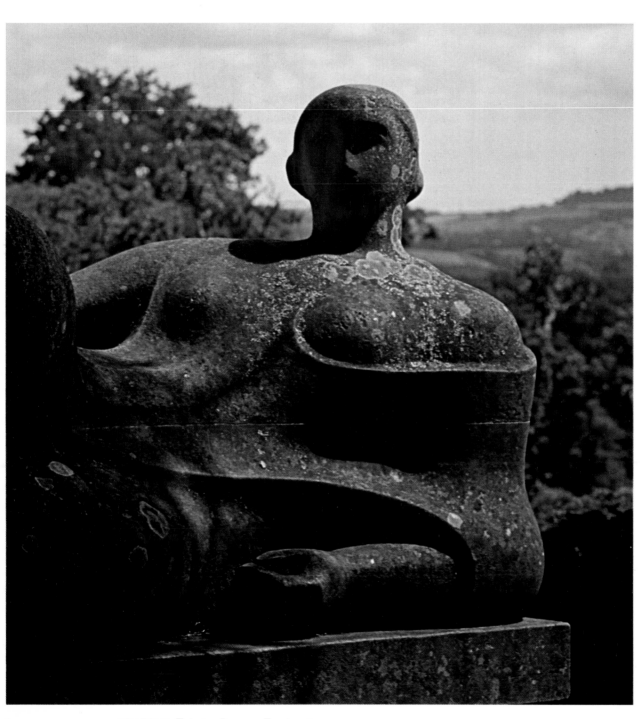

1 MEMORIAL FIGURE, 1945/46, Totnes, Devon, England

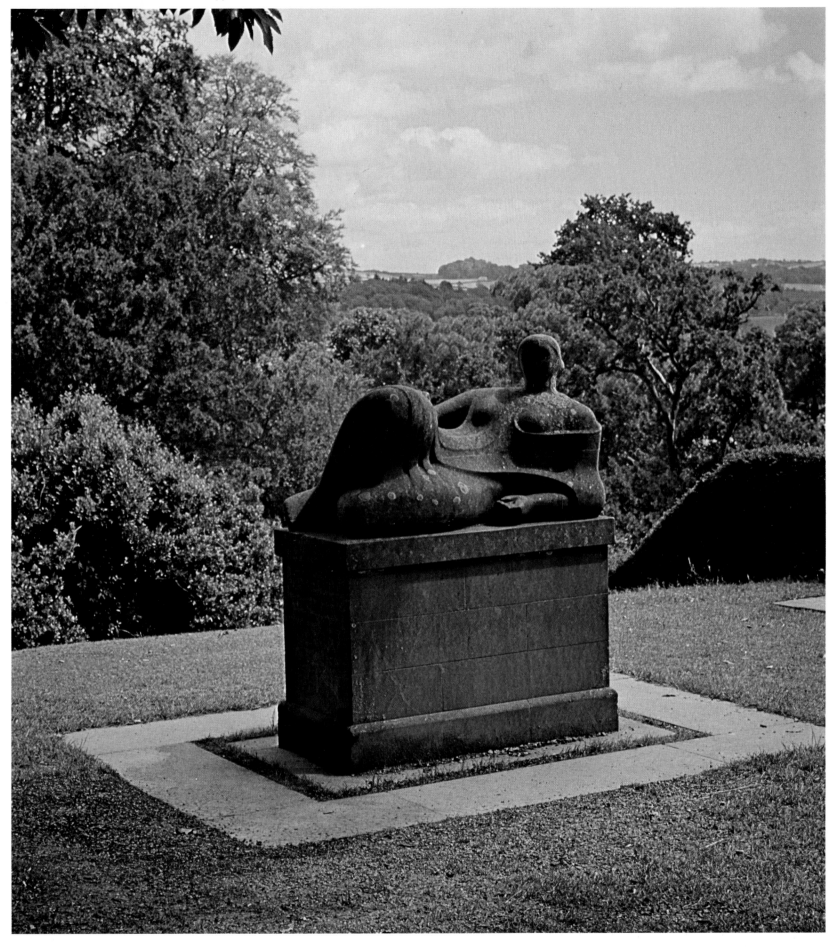

2 MEMORIAL FIGURE, 1945/46

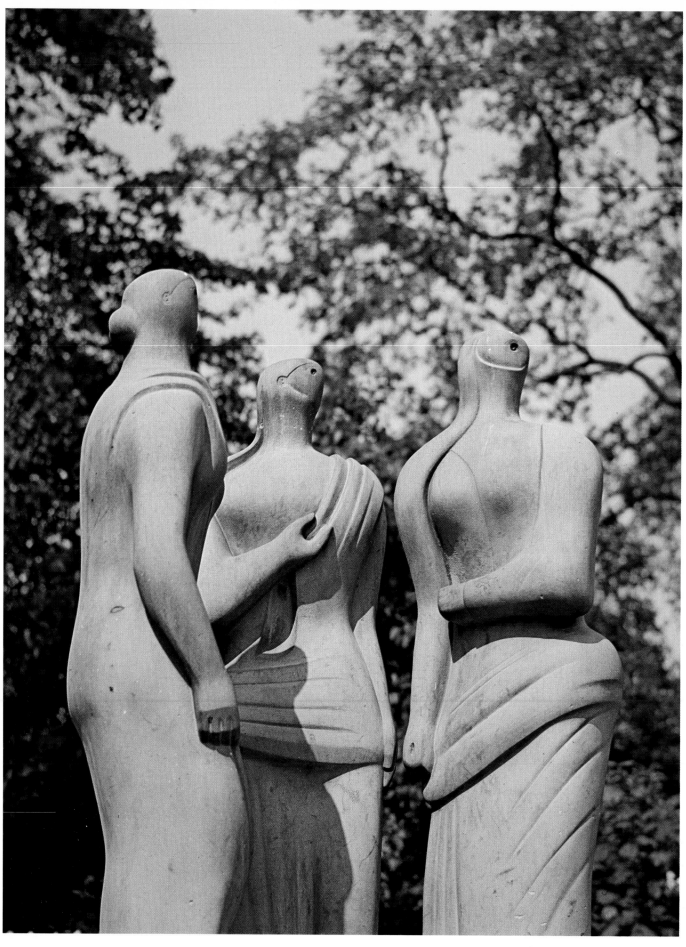

3 THREE STANDING FIGURES, 1947/48, Battersea Park, London, England

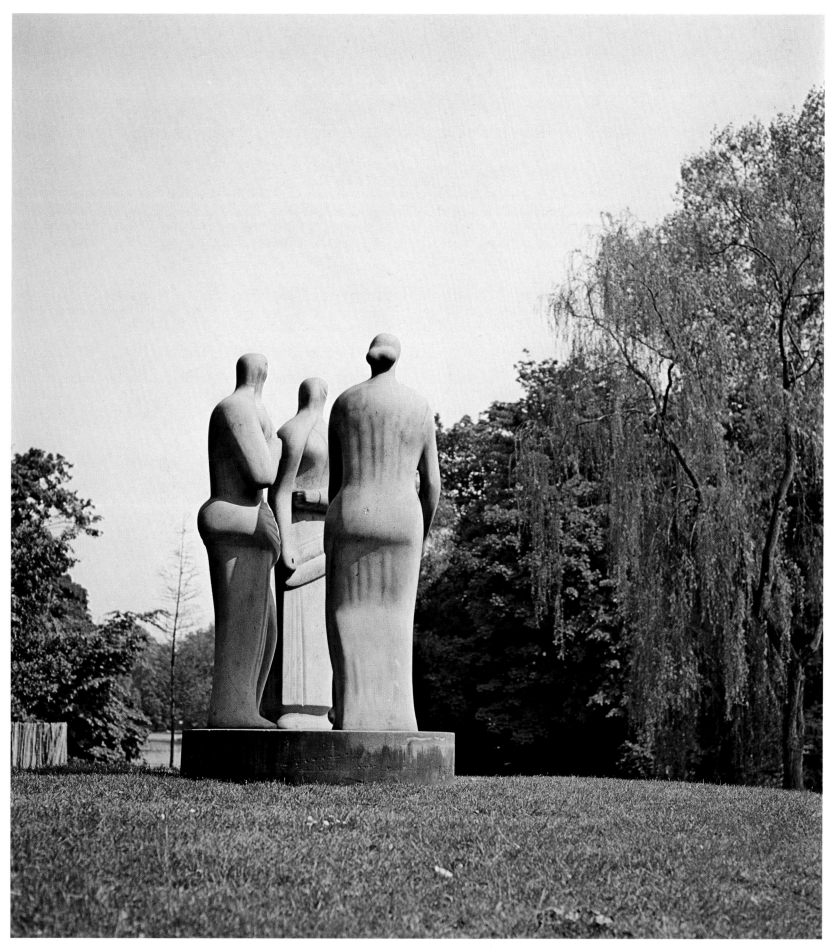

4 THREE STANDING FIGURES, 1947/48

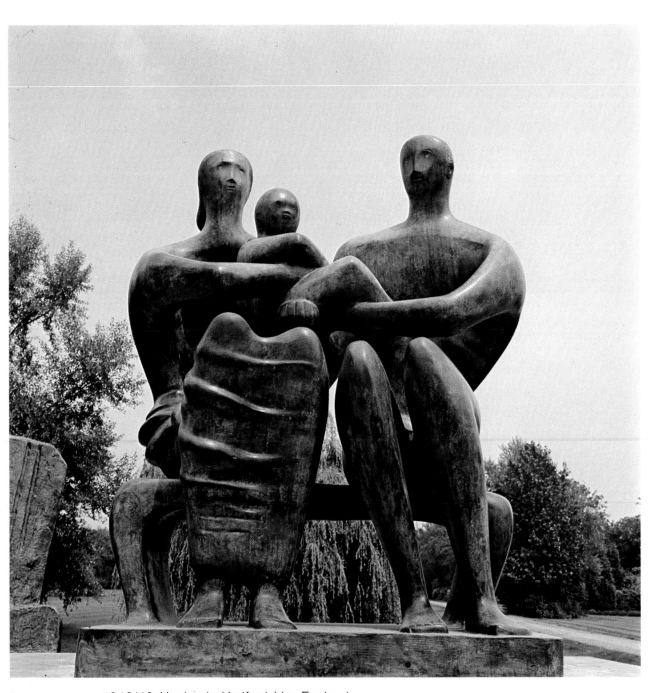

5 FAMILY GROUP, 1948/49, Hoglands, Hertfordshire, England

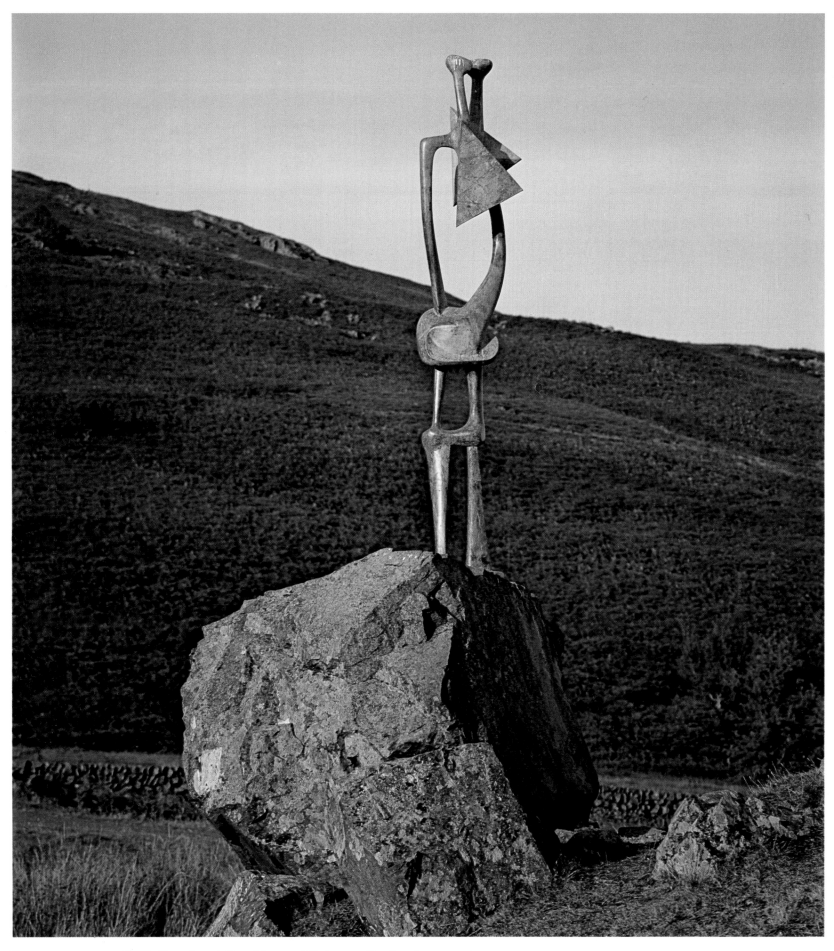

6 STANDING FIGURE, 1950, Shawhead, Dumfries and Galloway, Scotland

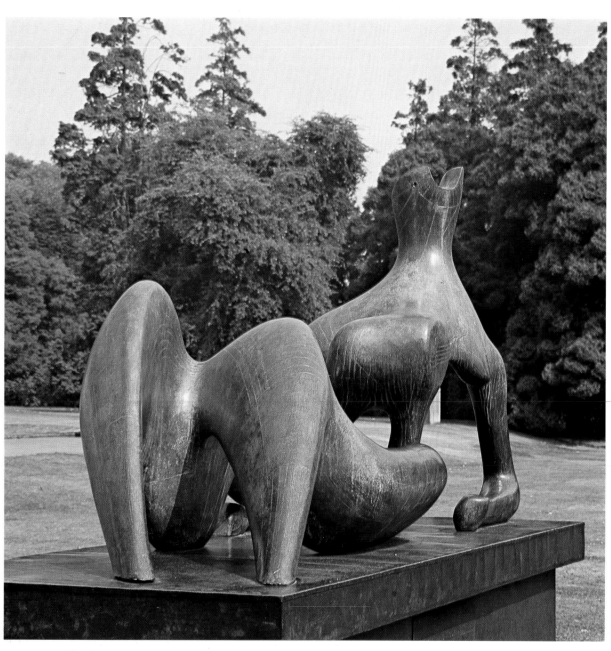

7 RECLINING FIGURE, 1951, Edinburgh, Scotland

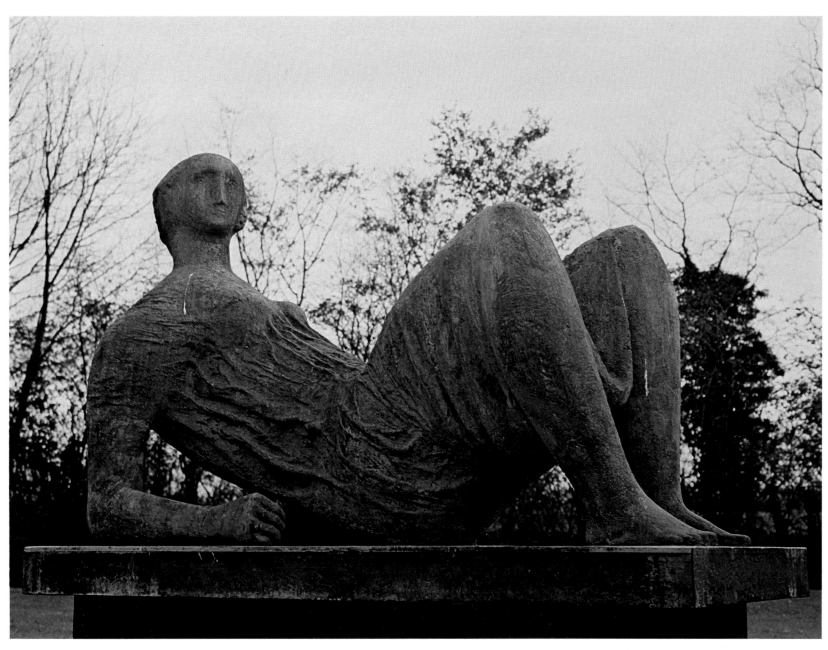

8 DRAPED RECLINING FIGURE, 1952/53, Hoglands, Hertfordshire, England

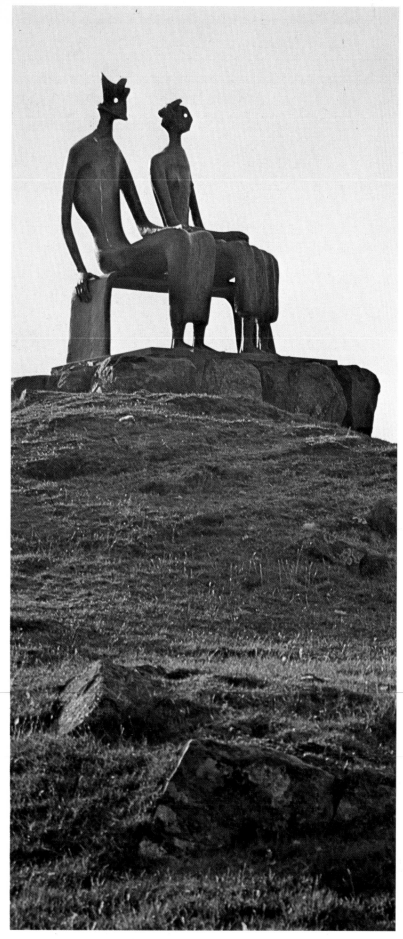

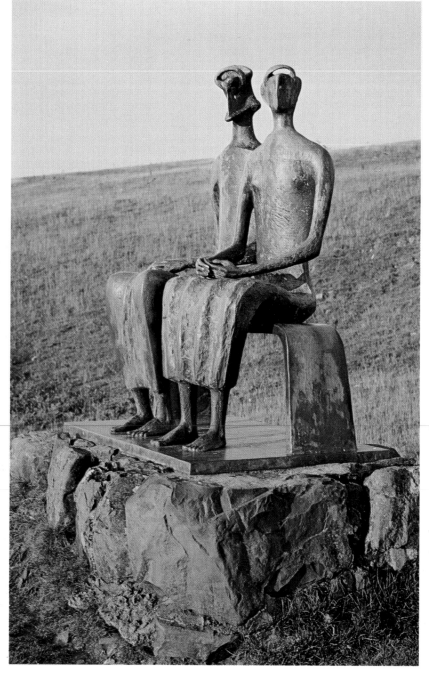

9 KING AND QUEEN, 1952/53 10 KING AND QUEEN, 1952/53

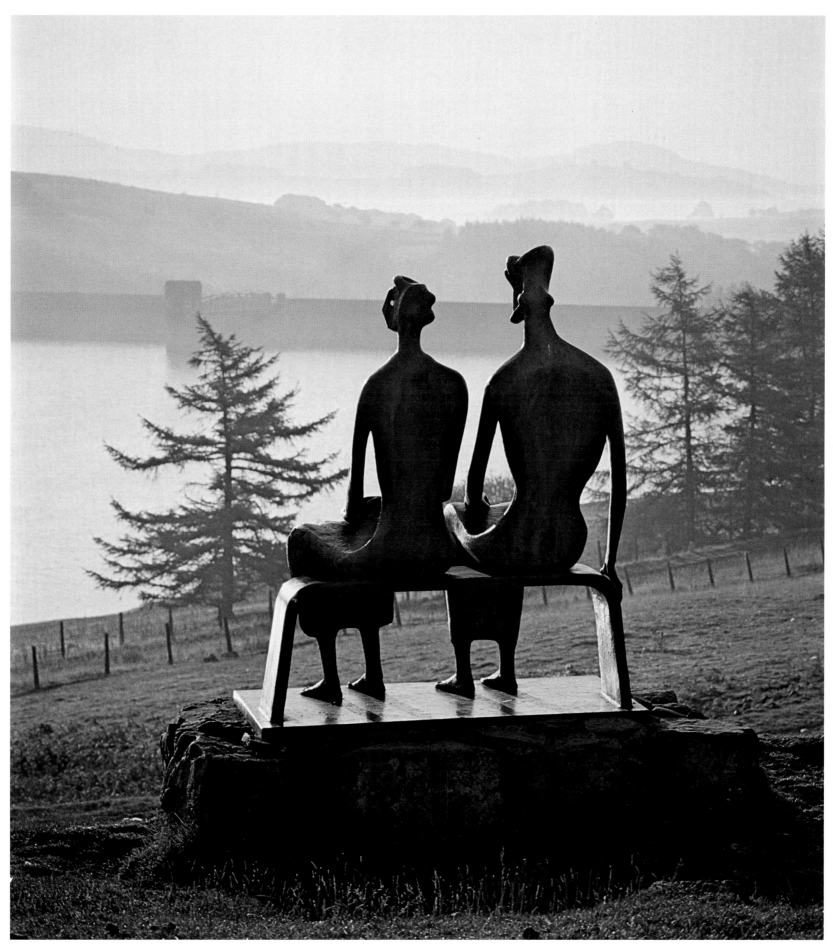

11 KING AND QUEEN, 1952/53, Shawhead, Dumfries and Galloway, Scotland

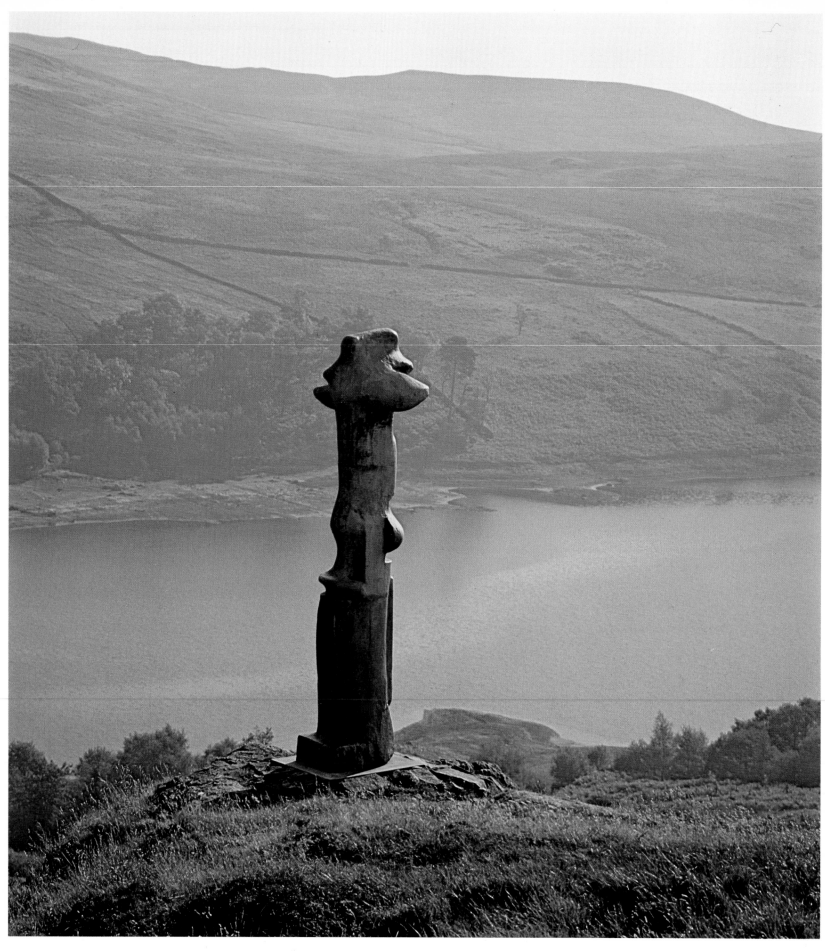

12 UPRIGHT MOTIVE NO. 1: GLENKILN CROSS, 1955/56, Shawhead, Dumfries and Galloway, Scotland

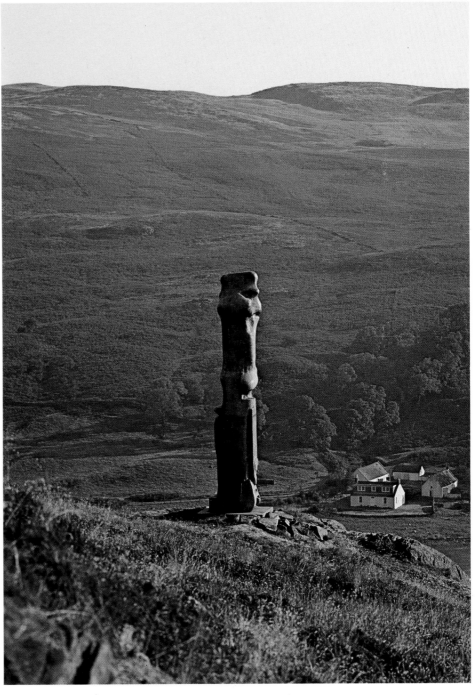

13 UPRIGHT MOTIVE NO. 1: GLENKILN CROSS, 1955/56 14 UPRIGHT MOTIVE NO. 1: GLENKILN CROSS, 1955/56

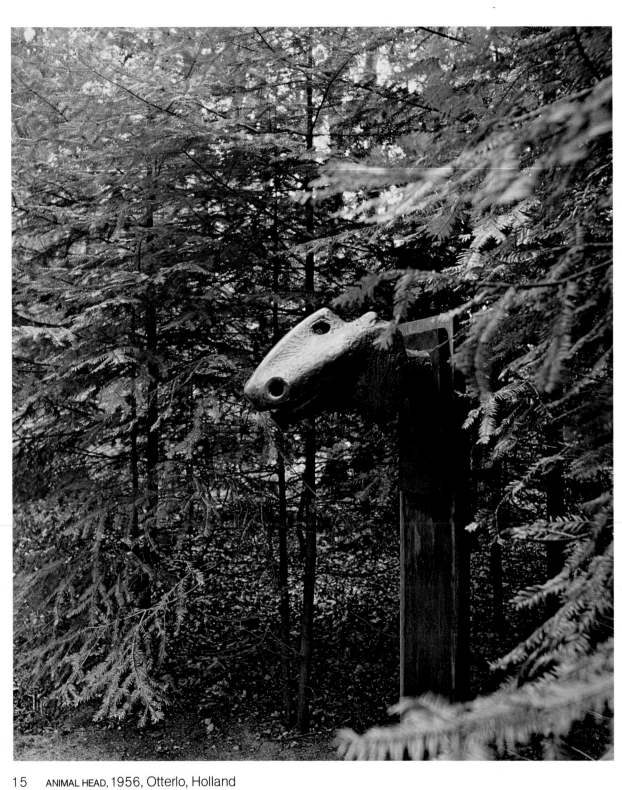

15 ANIMAL HEAD, 1956, Otterlo, Holland

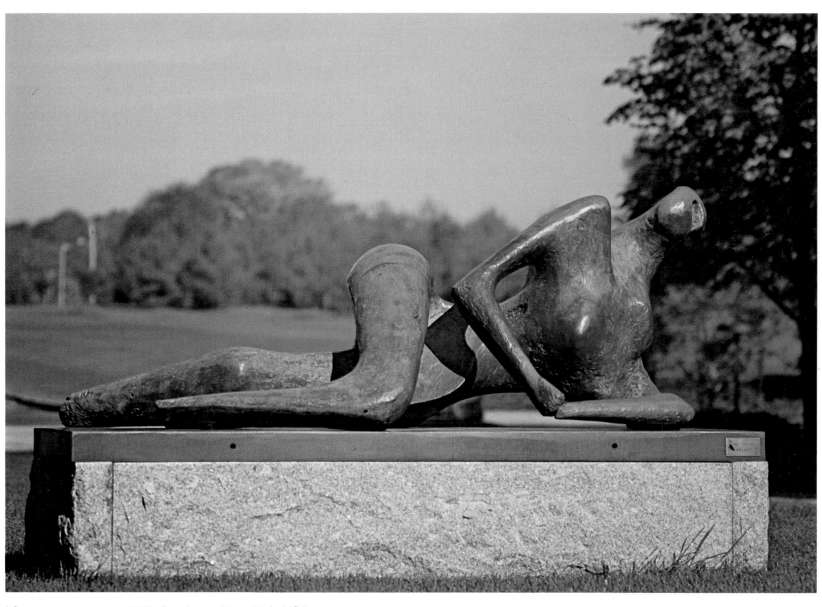

16 RECLINING FIGURE, 1956, Purchase, New York, USA

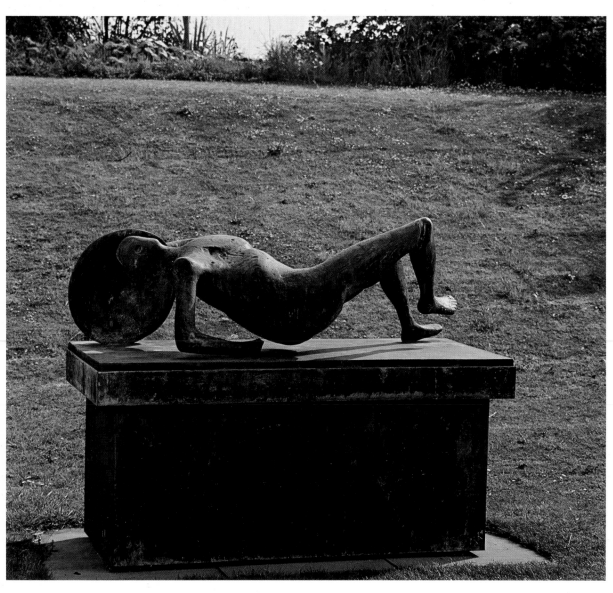

17 FALLING WARRIOR, 1956/57, Chichester, Sussex, England

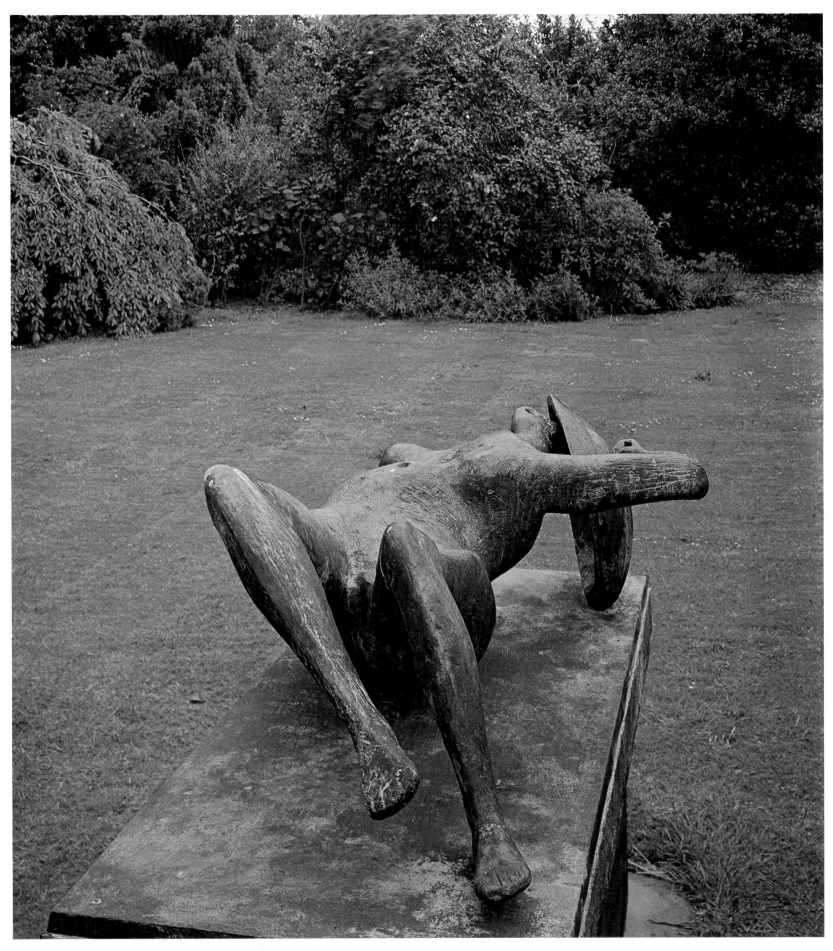

18 FALLING WARRIOR, 1956/57

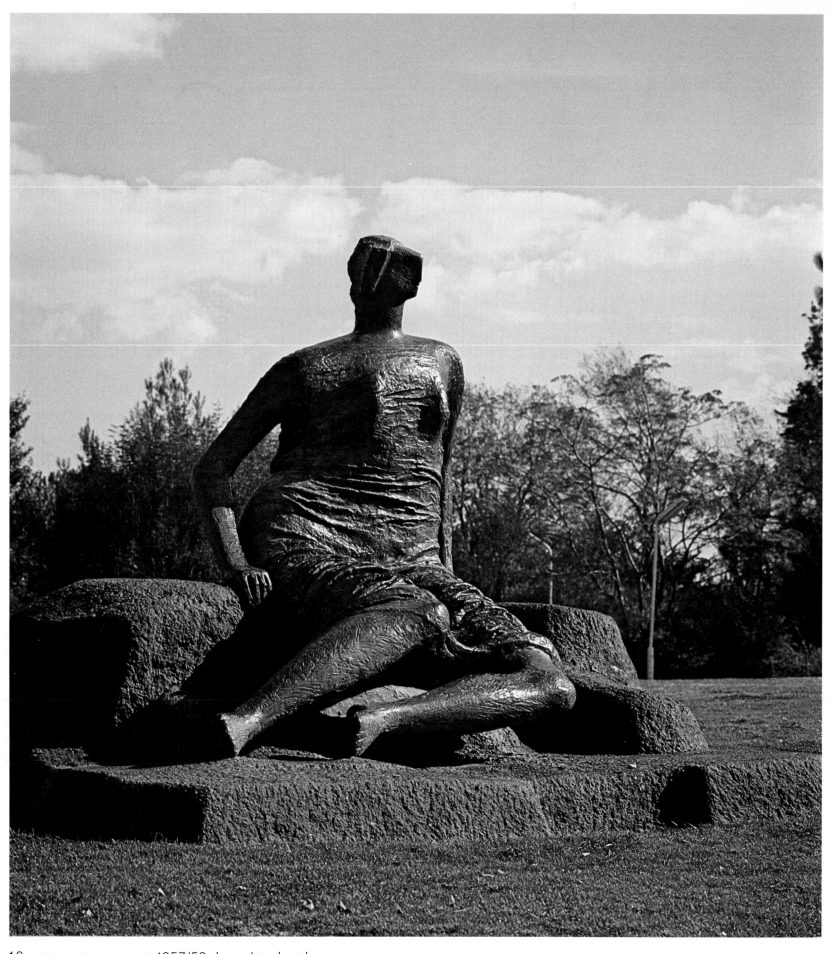

19 DRAPED SEATED WOMAN, 1957/58, Jerusalem, Israel

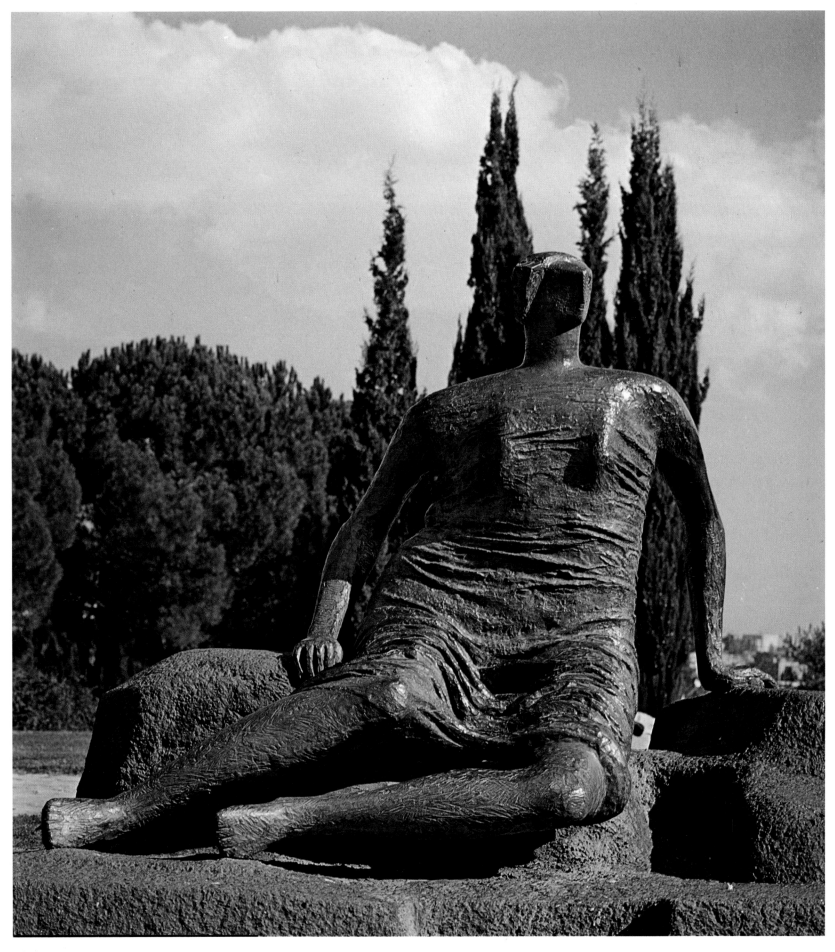

20 DRAPED SEATED WOMAN, 1957/58

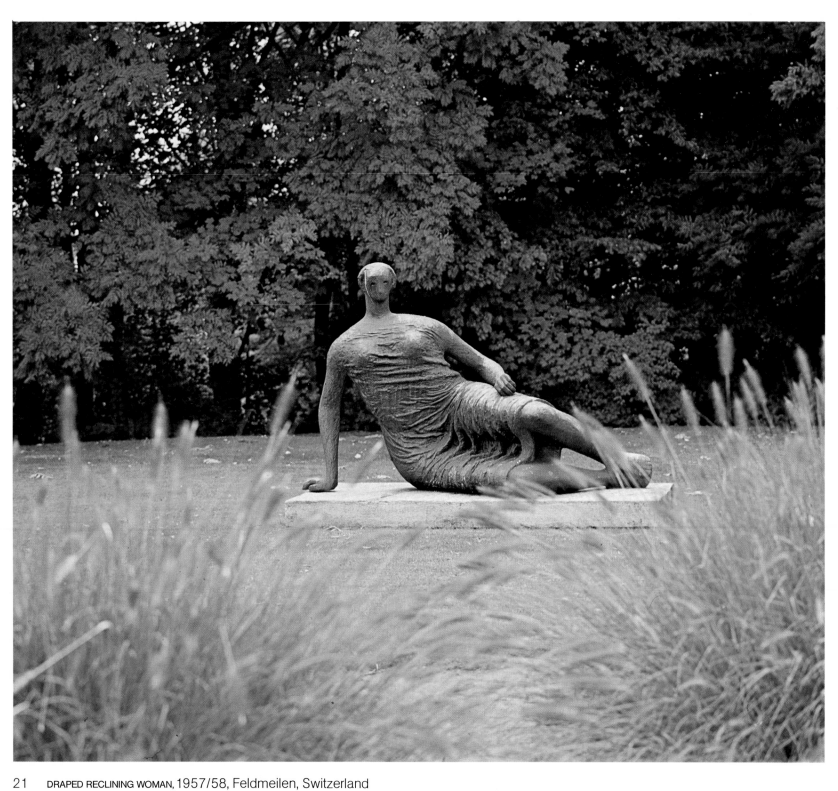

21 DRAPED RECLINING WOMAN, 1957/58, Feldmeilen, Switzerland

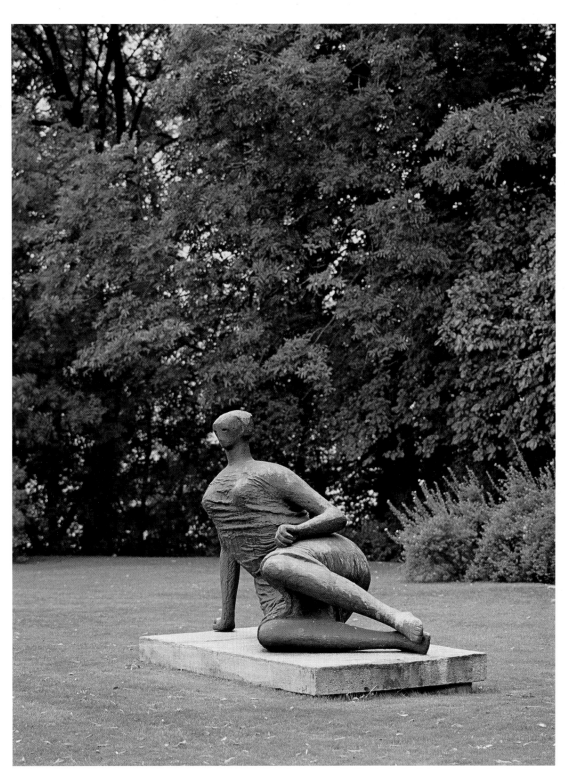

22 DRAPED RECLINING WOMAN, 1957/58

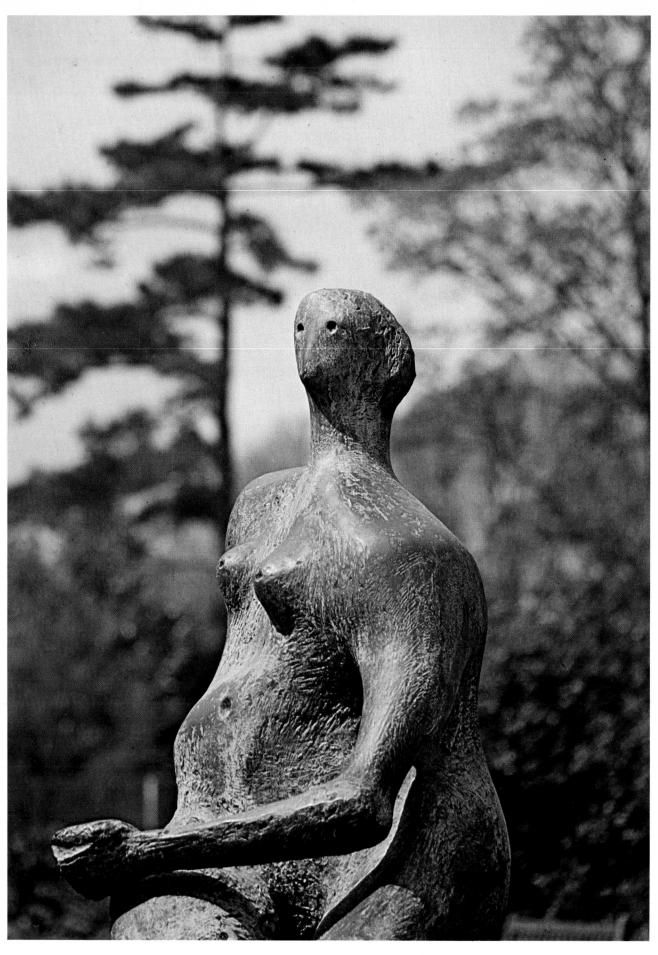

23 SEATED WOMAN, 1957, Orford, Suffolk, England

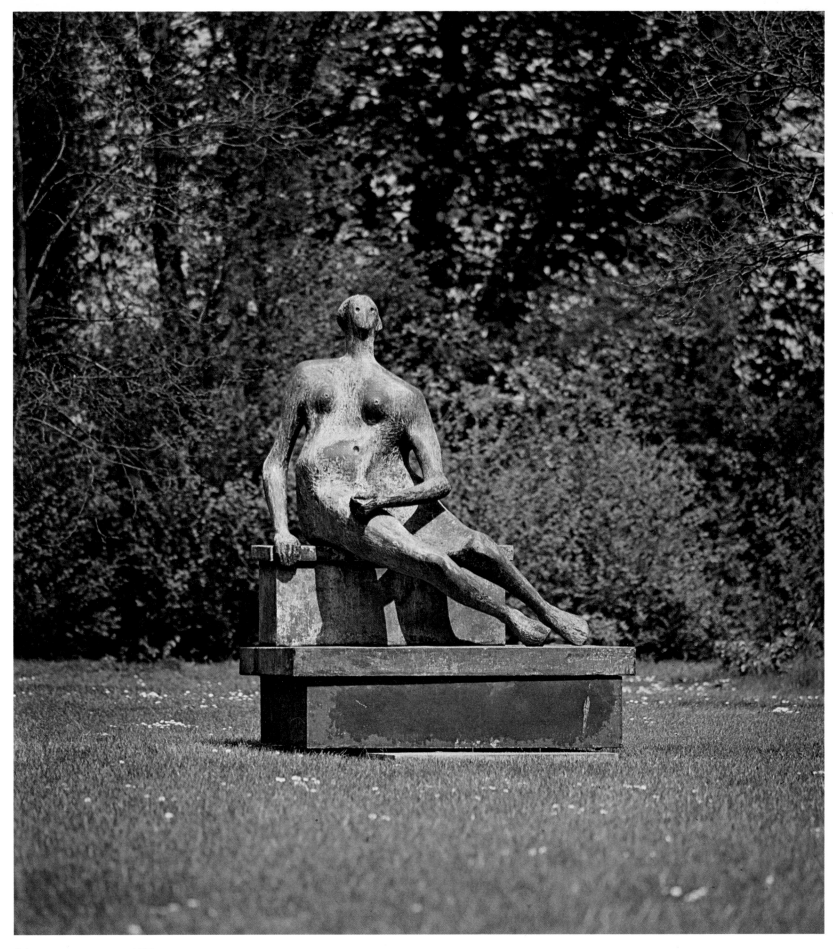

24 SEATED WOMAN, 1957

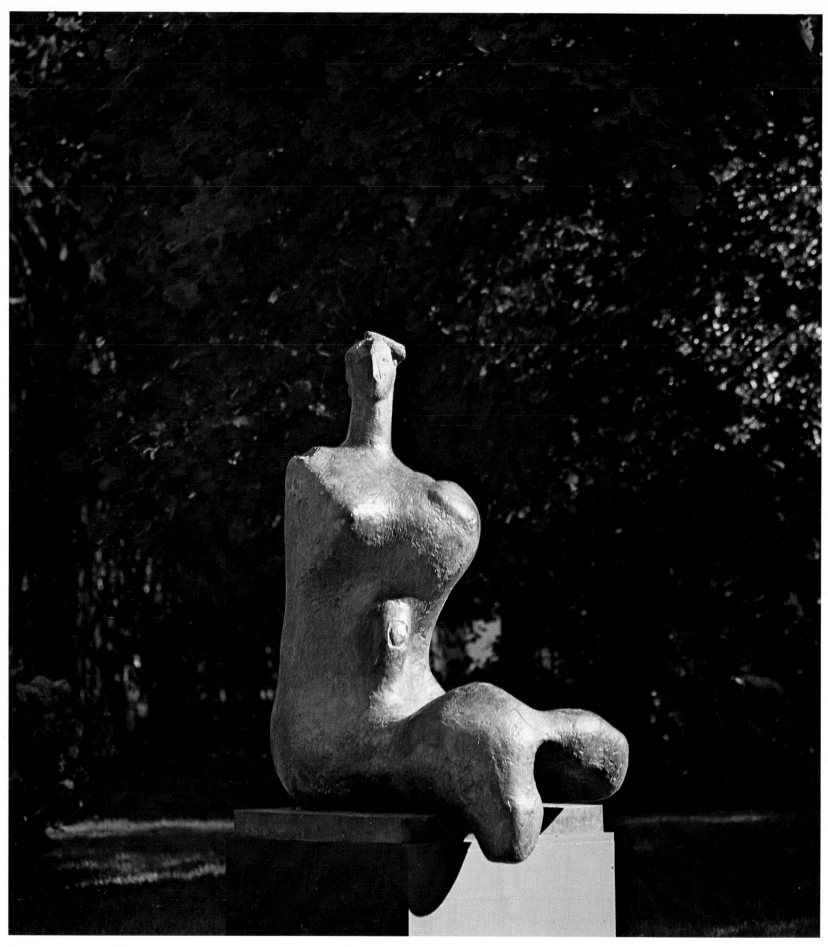

25 WOMAN, 1957/58, Bregenz Exhibition 1977, Austria

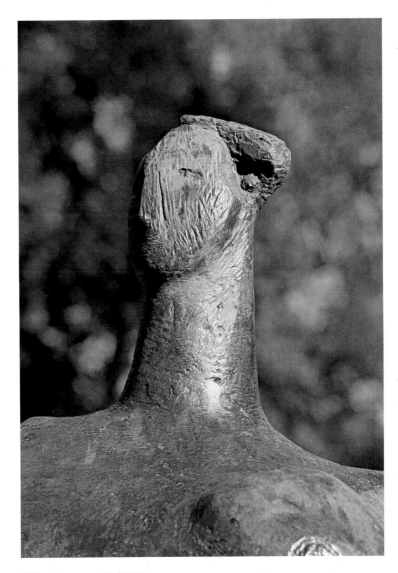

26 WOMAN, 1957/58

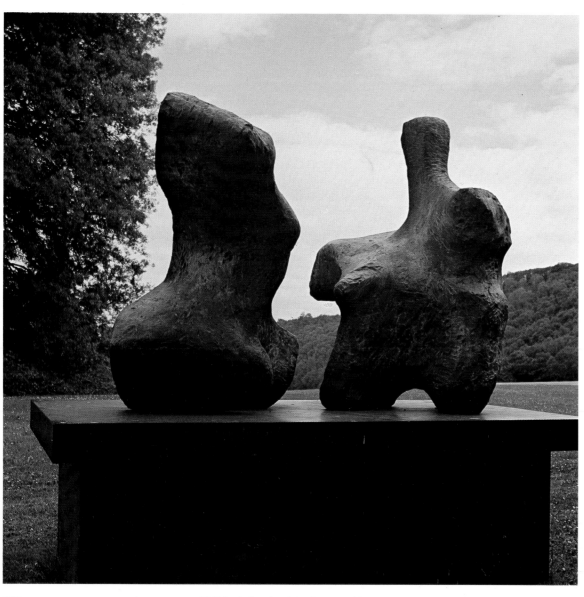

27 TWO PIECE RECLINING FIGURE NO. 1, 1959, Ashprington, Devon, England

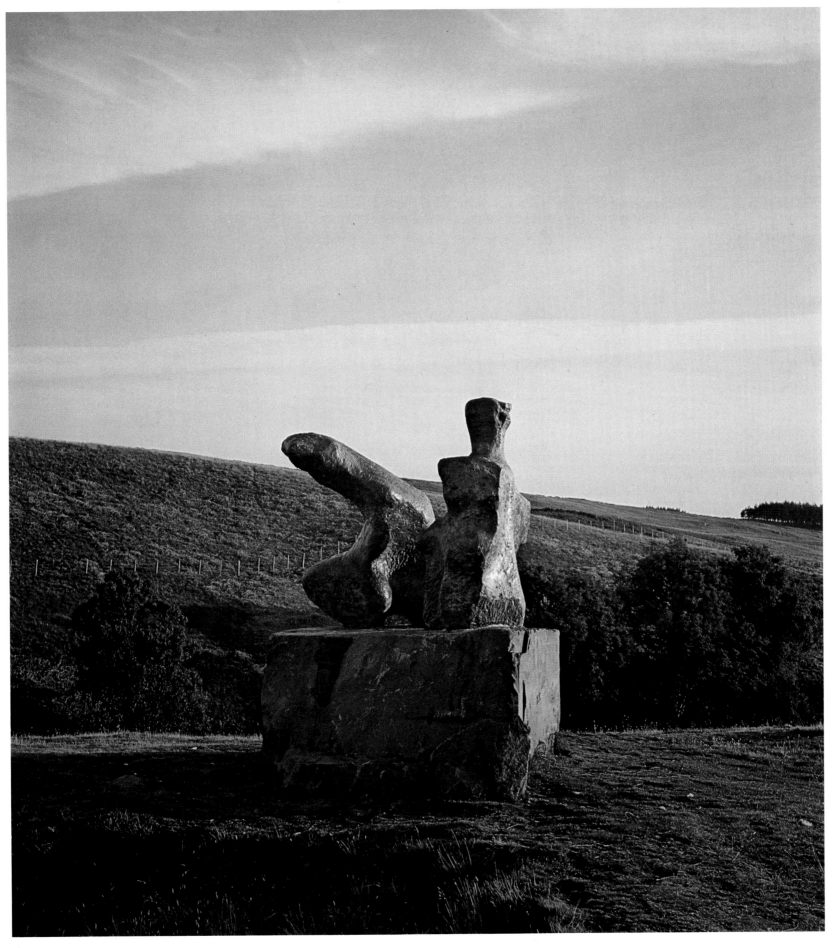

28 TWO PIECE RECLINING FIGURE NO. 1, 1959, Shawhead, Dumfries and Galloway, Scotland

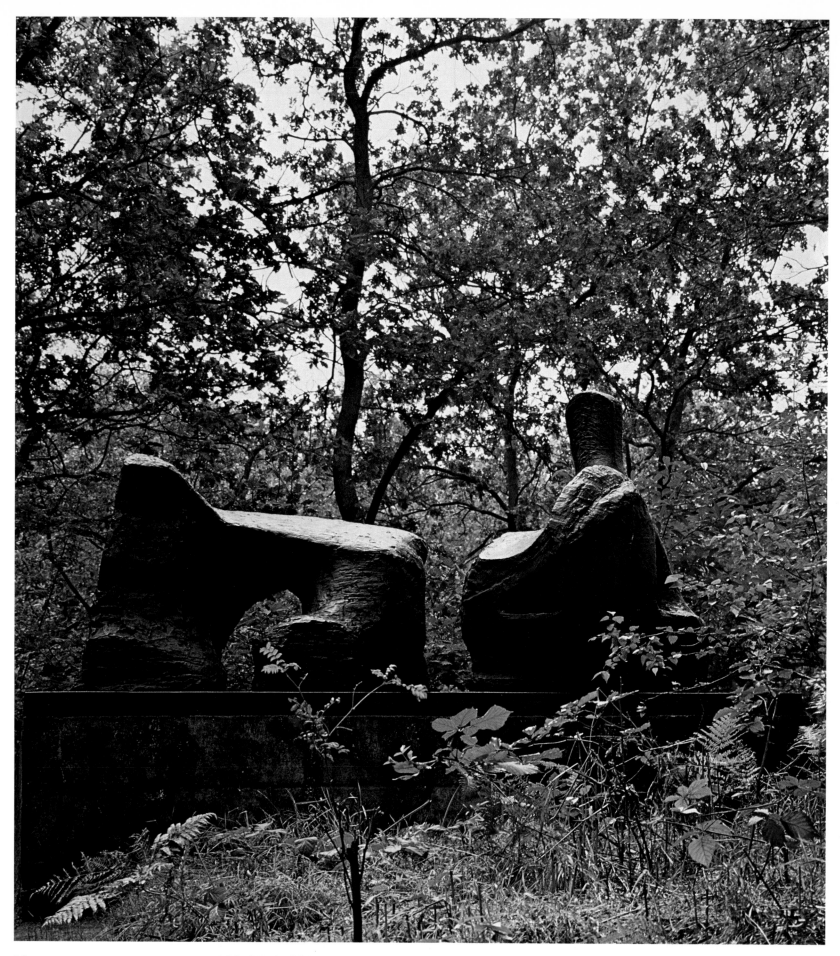

29 TWO PIECE RECLINING FIGURE NO. 2, 1960, Otterlo, Holland

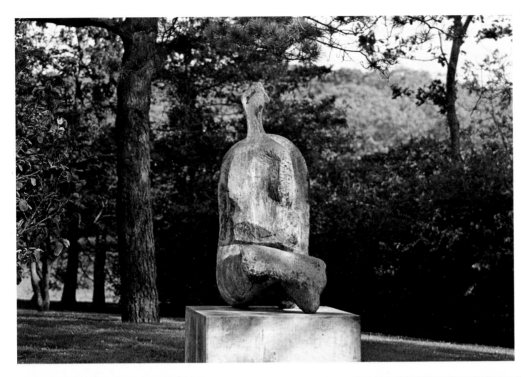

SEATED WOMAN-THIN NECK, 1961,
East Hampton, Connecticut, USA

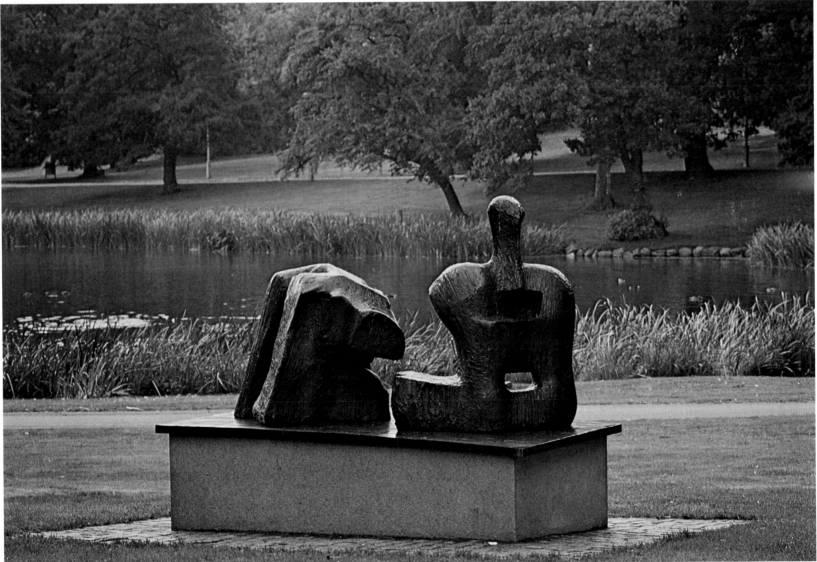

31 TWO PIECE RECLINING FIGURE NO. 3, 1961, Gothenburg, Sweden

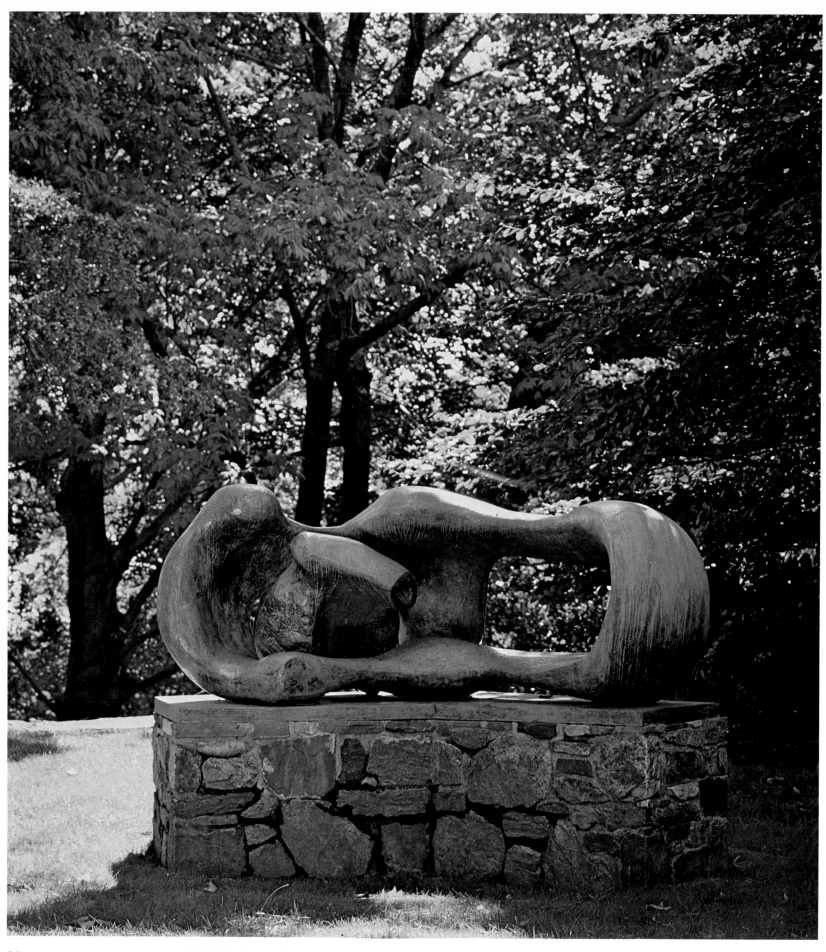

32 RECLINING MOTHER AND CHILD, 1960/61, Byram, Connecticut, USA

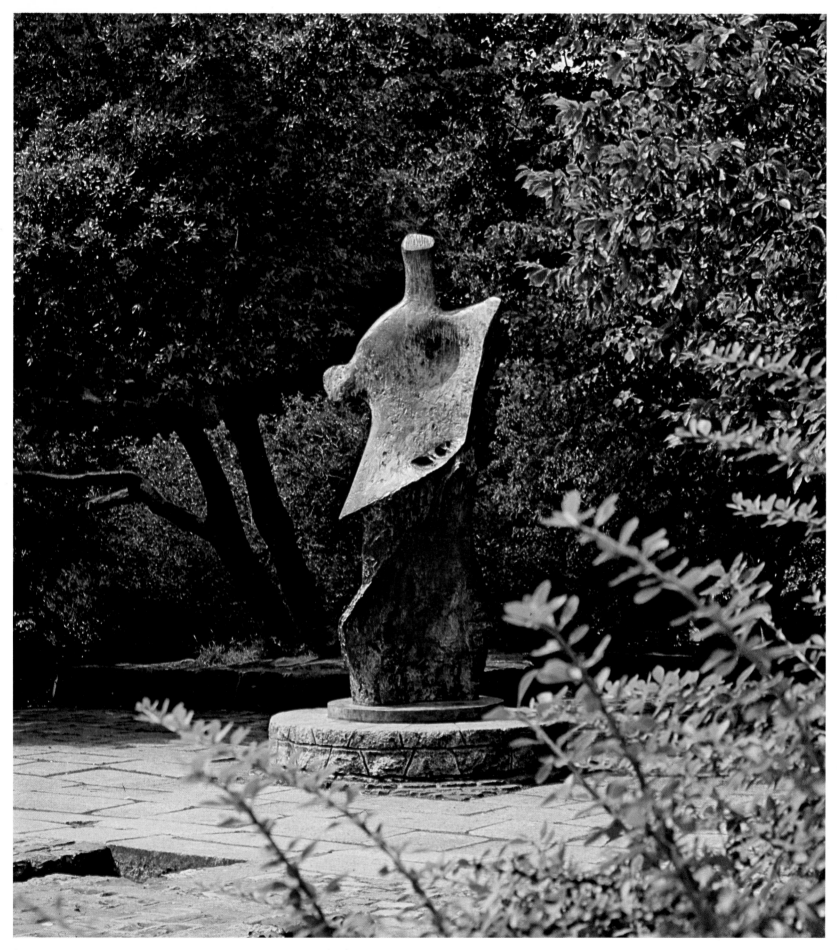

33 STANDING FIGURE KNIFE EDGE, 1961, Dublin, Ireland

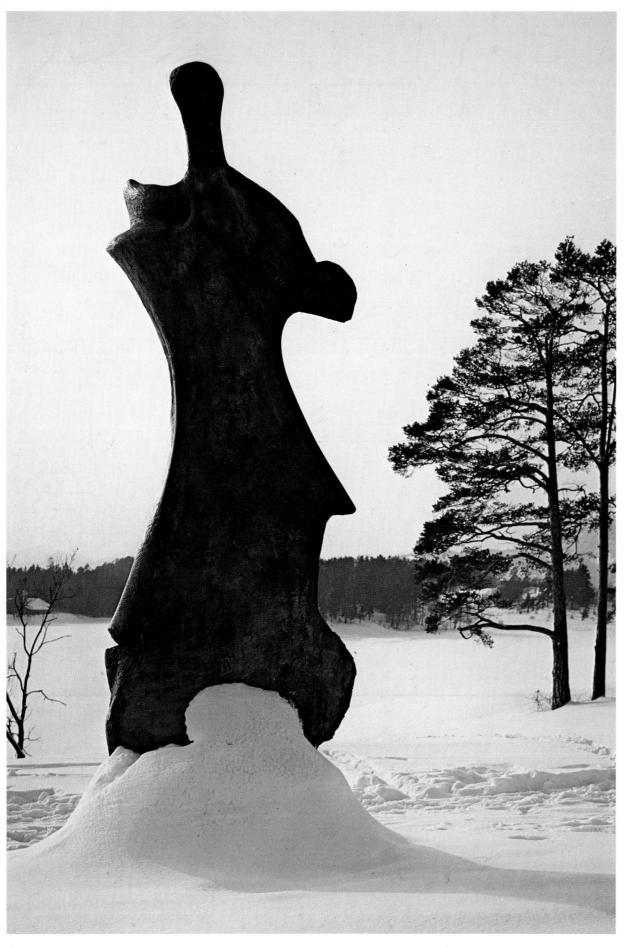

34 LARGE STANDING FIGURE KNIFE EDGE, 1961/76, Høvikodden, Oslo, Norway

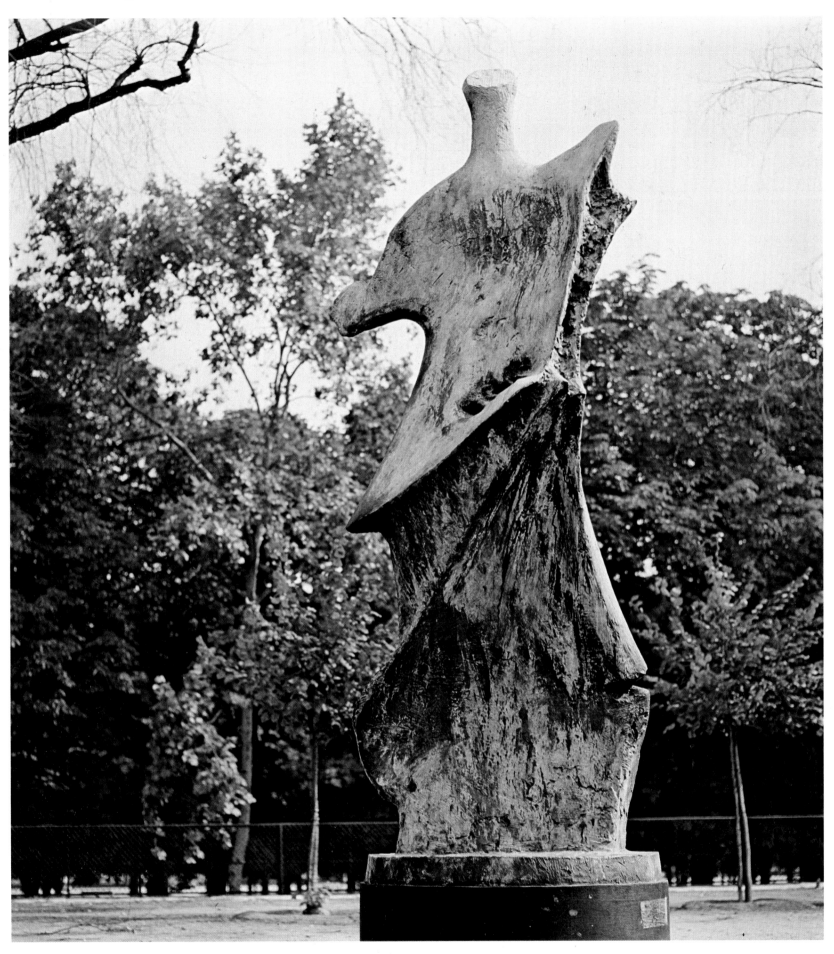

35 LARGE STANDING FIGURE KNIFE EDGE, 1961/76, Paris Exhibition 1977, France

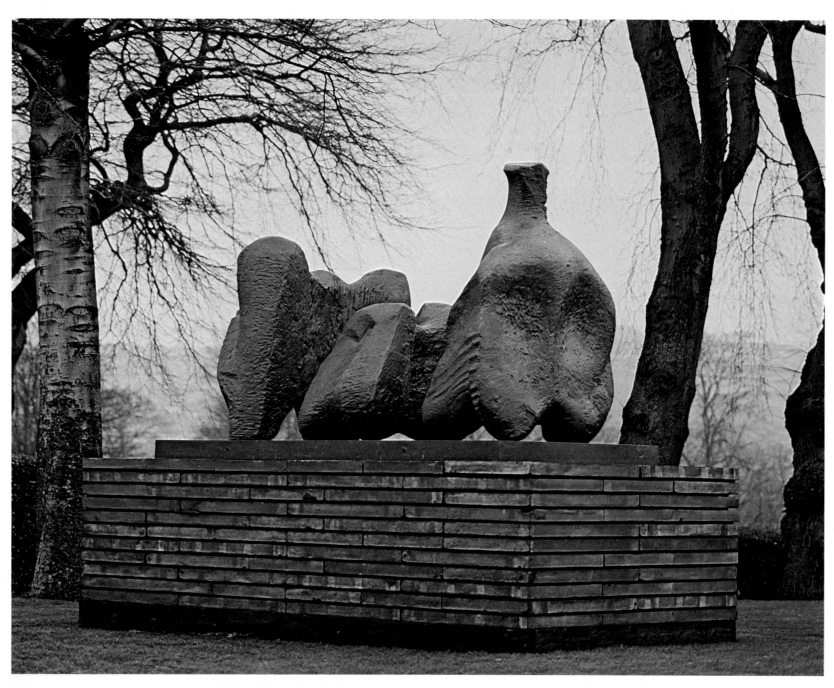

36 THREE PIECE RECLINING FIGURE NO. 1, 1961/62, Bradford Exhibition 1978, West Yorkshire, England

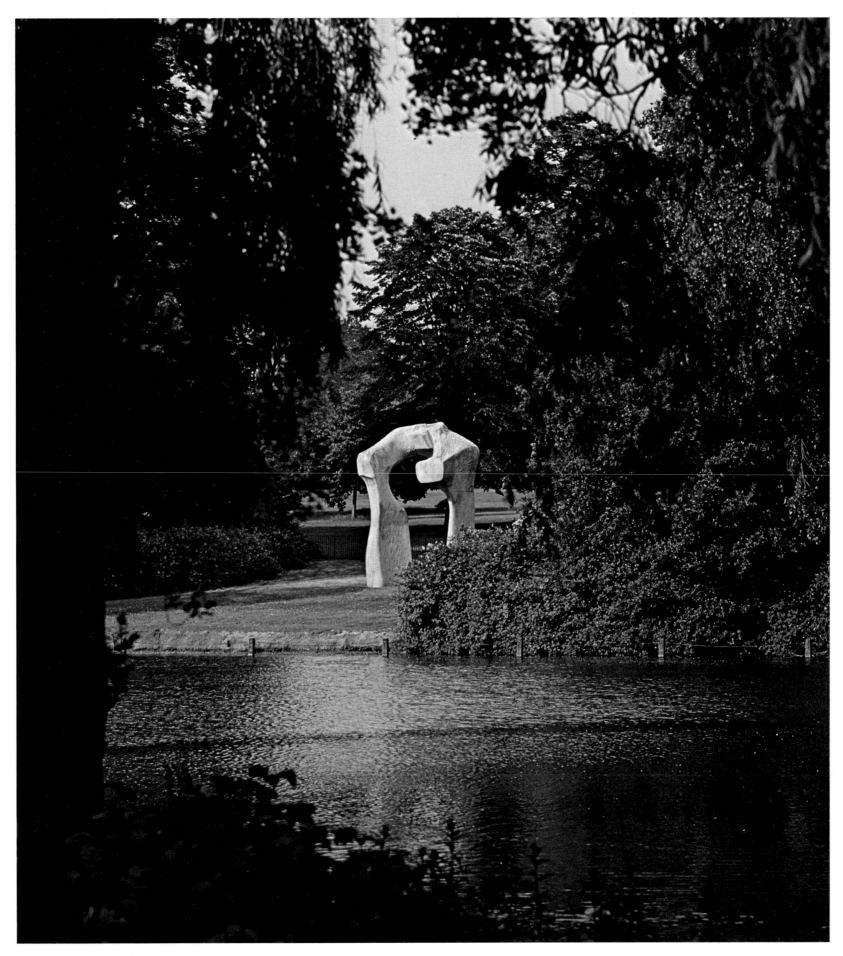

37 THE ARCH, 1963/69, Arts Council Exhibition 1978, Kensington Gardens, London, England

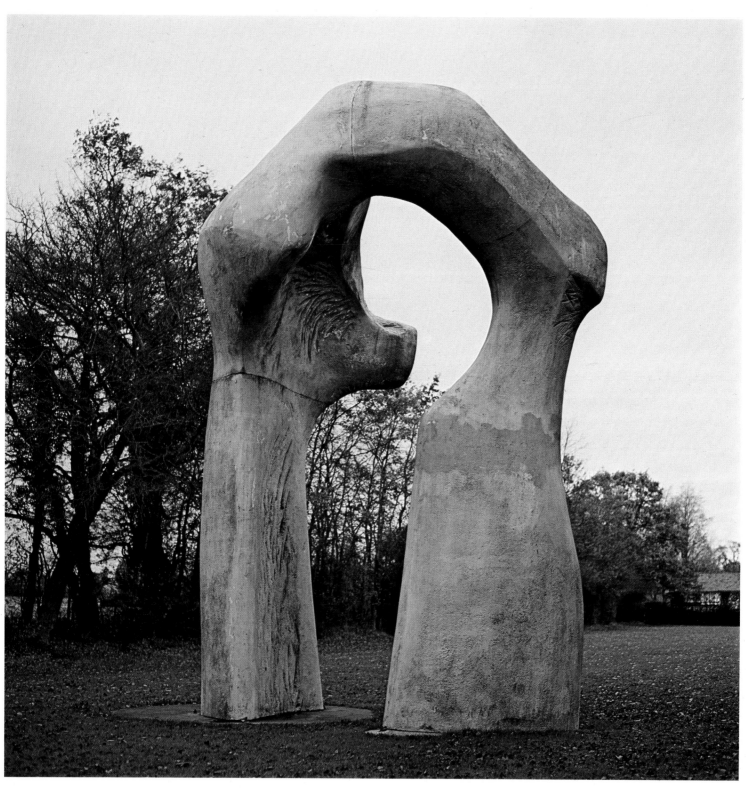

38 THE ARCH, 1963/69, Hoglands, Hertfordshire, England

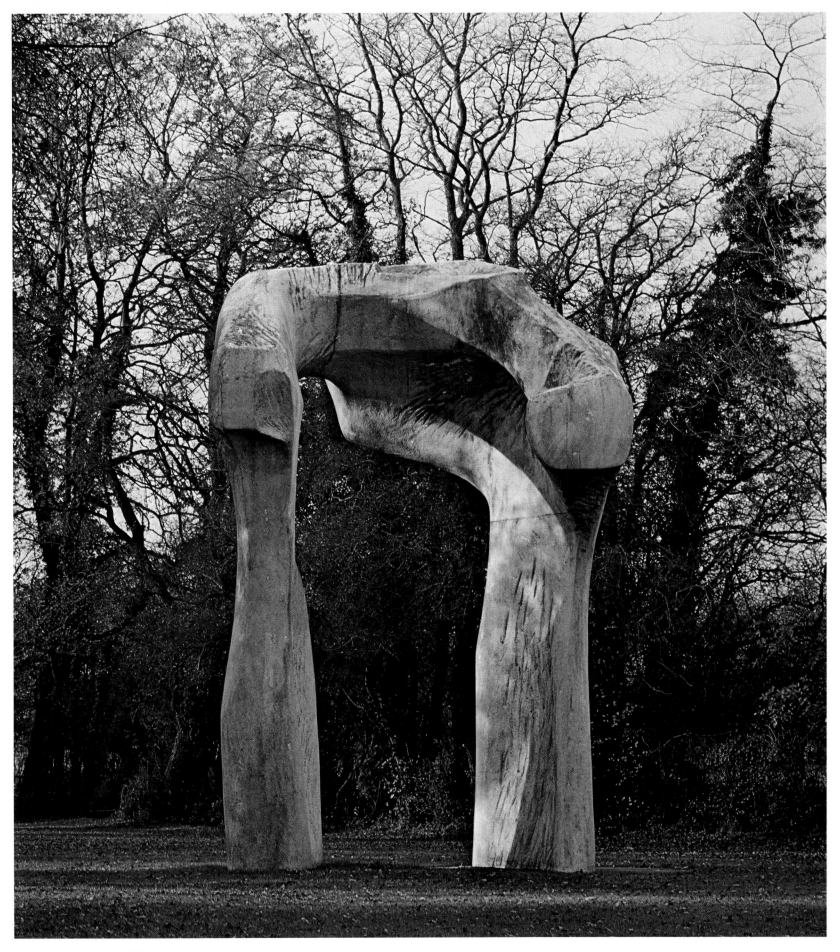

39 THE ARCH, 1963/69

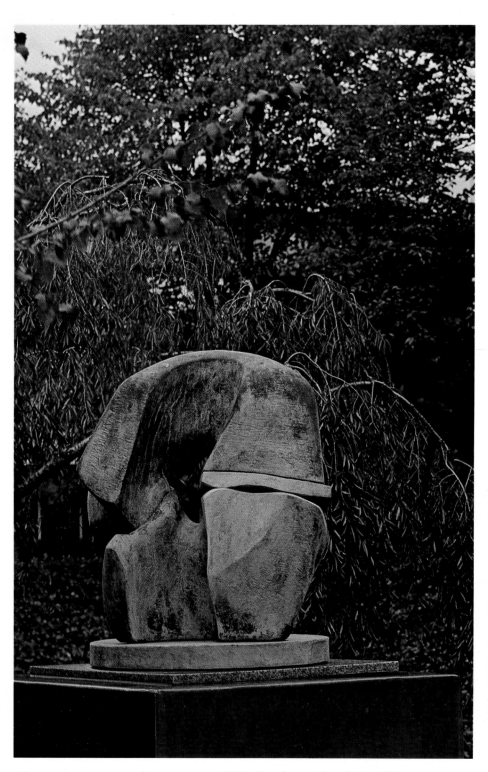

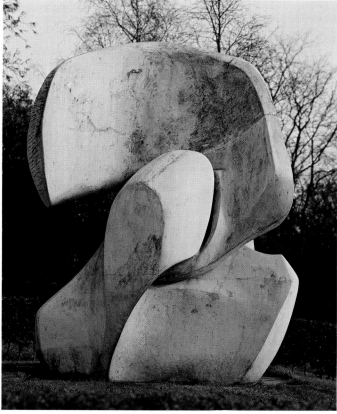

40 WORKING MODEL FOR LOCKING PIECE, 1962, Purchase, New York, USA 41 LOCKING PIECE, 1963/64

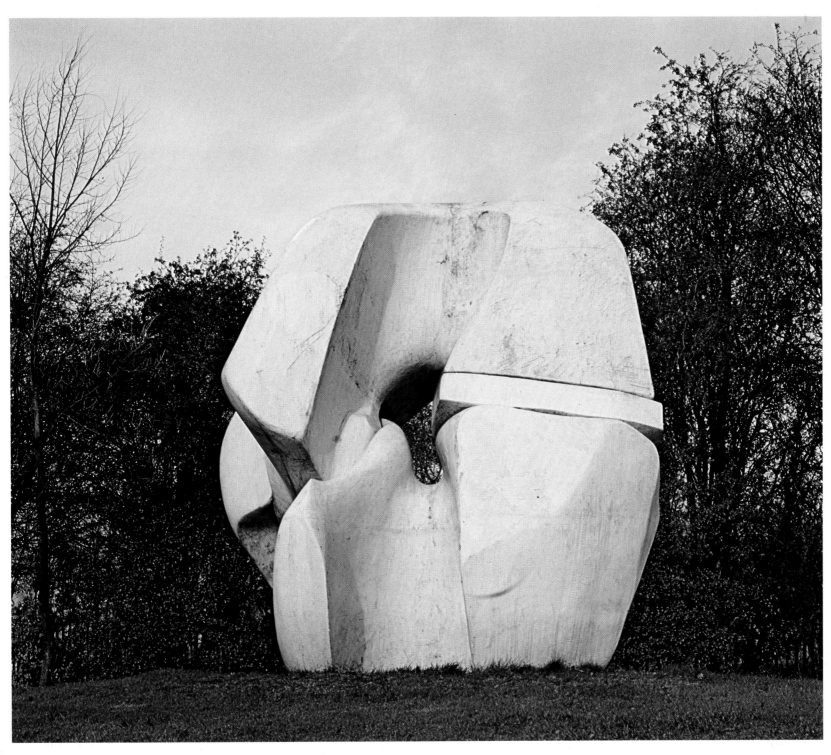

42 LOCKING PIECE, 1963/64, Hoglands, Hertfordshire, England

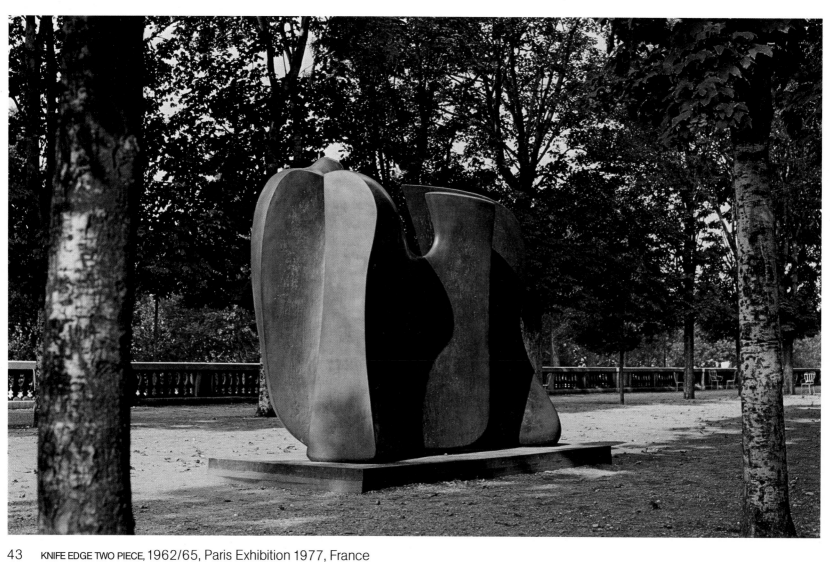

43 KNIFE EDGE TWO PIECE, 1962/65, Paris Exhibition 1977, France

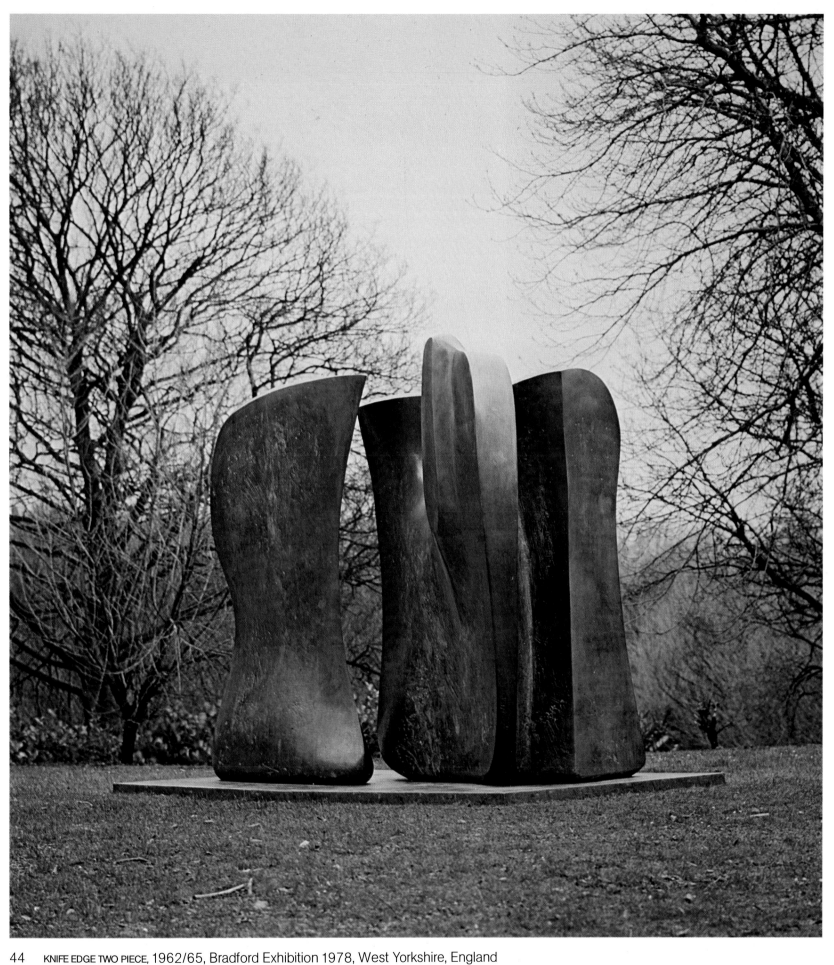

44 KNIFE EDGE TWO PIECE, 1962/65, Bradford Exhibition 1978, West Yorkshire, England

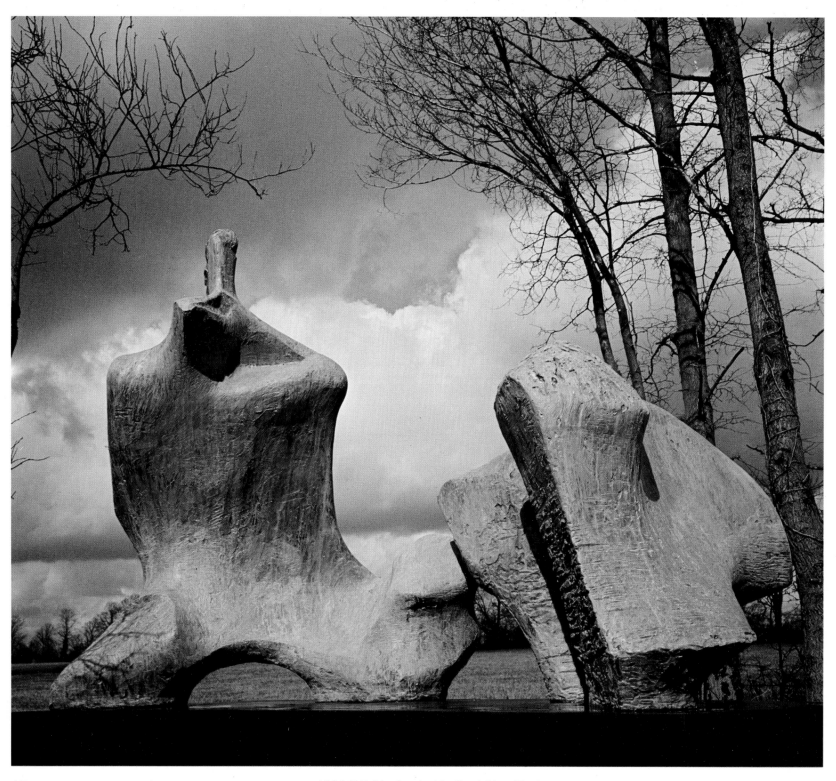

45 WORKING MODEL FOR RECLINING FIGURE (LINCOLN CENTER), 1963/65, Hoglands, Hertfordshire, England

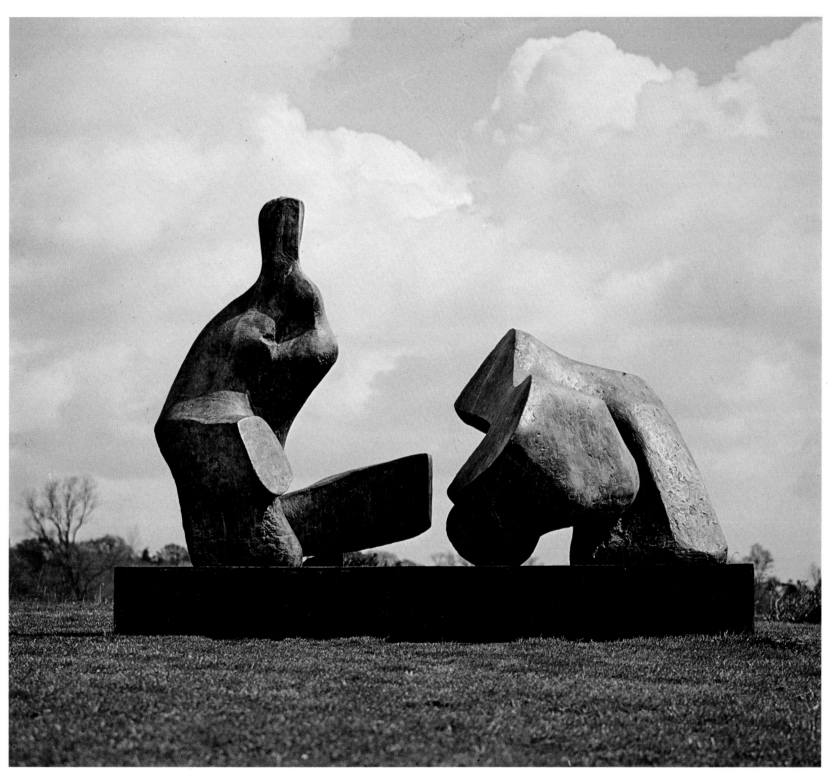

46 TWO PIECE RECLINING FIGURE NO. 5, 1963/64, Aldeburgh, Suffolk, England

47 TWO PIECE RECLINING FIGURE NO. 5, 1963/64, Humlebæk, Denmark

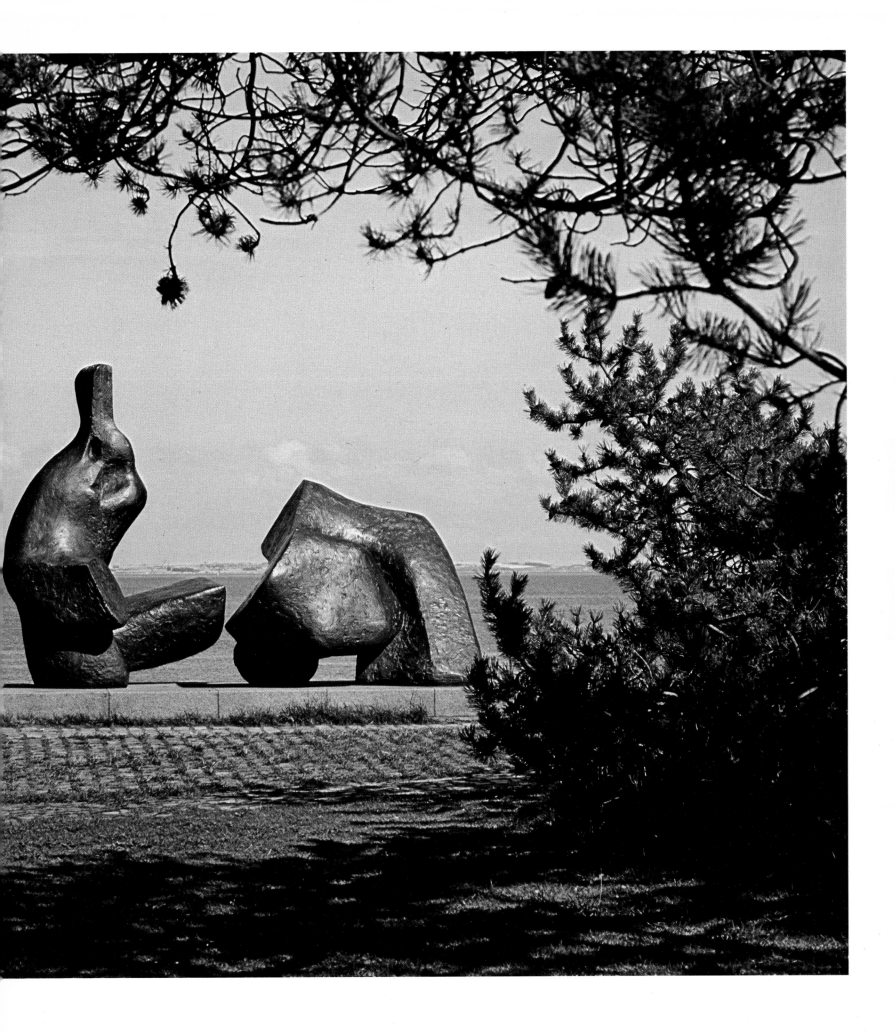

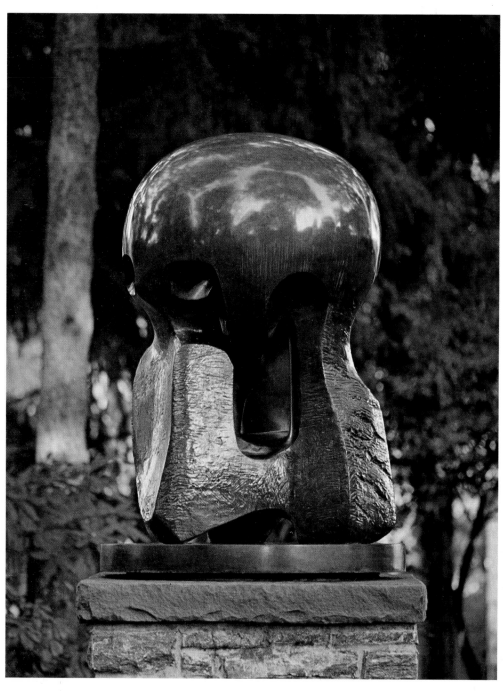

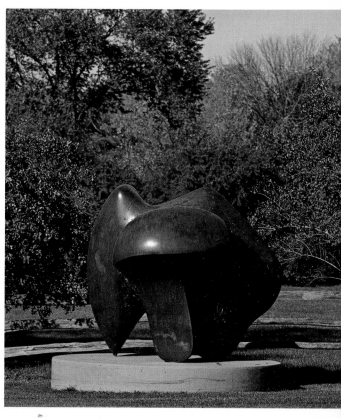

48 ATOM PIECE, 1964/65, Lutherville, Maryland, USA

49 THREE WAY PIECE NO. 1 POINTS, 1964/65,
Lake Forest, Chicago, Illinois, USA

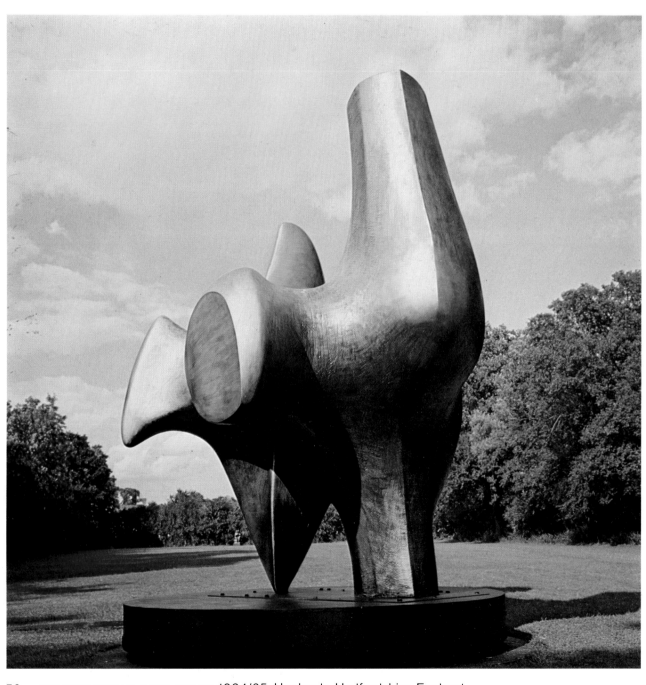

50 THREE WAY PIECE NO. 2 (THE) ARCHER, 1964/65, Hoglands, Hertfordshire, England

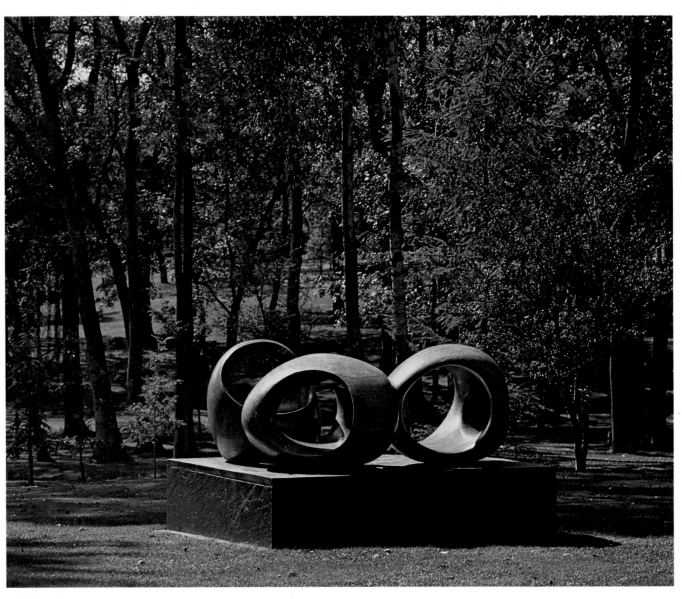

51 THREE RINGS, 1966, Lutherville, Maryland, USA

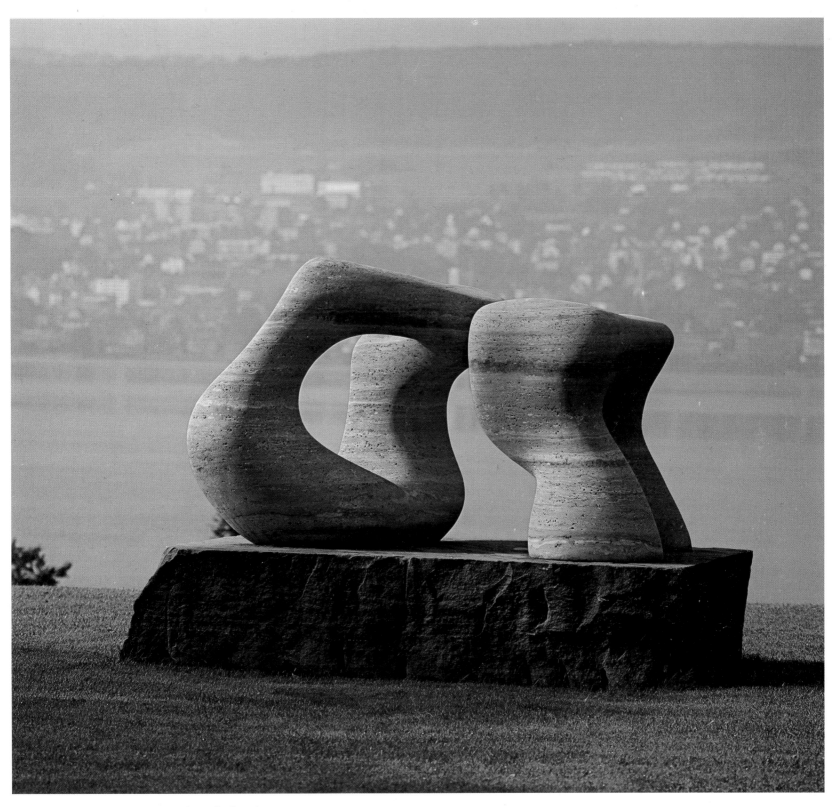

52 TWO FORMS, 1966, Feldmeilen, Switzerland

53 LARGE TWO FORMS, 1966/69, Florence Exhibition 1972, Italy

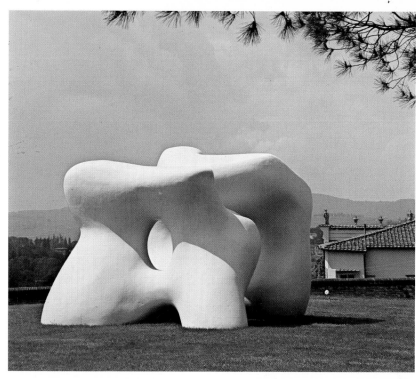

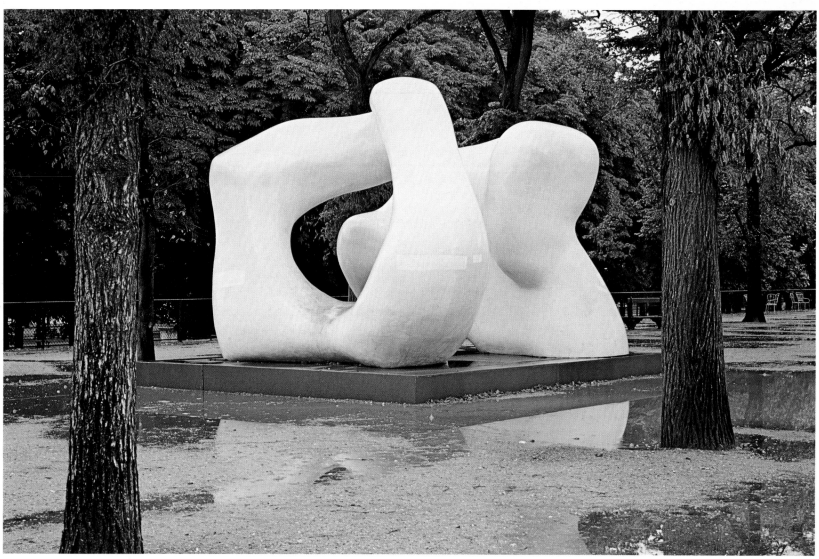

54 LARGE TWO FORMS, 1966/69, Paris Exhibition 1977, France

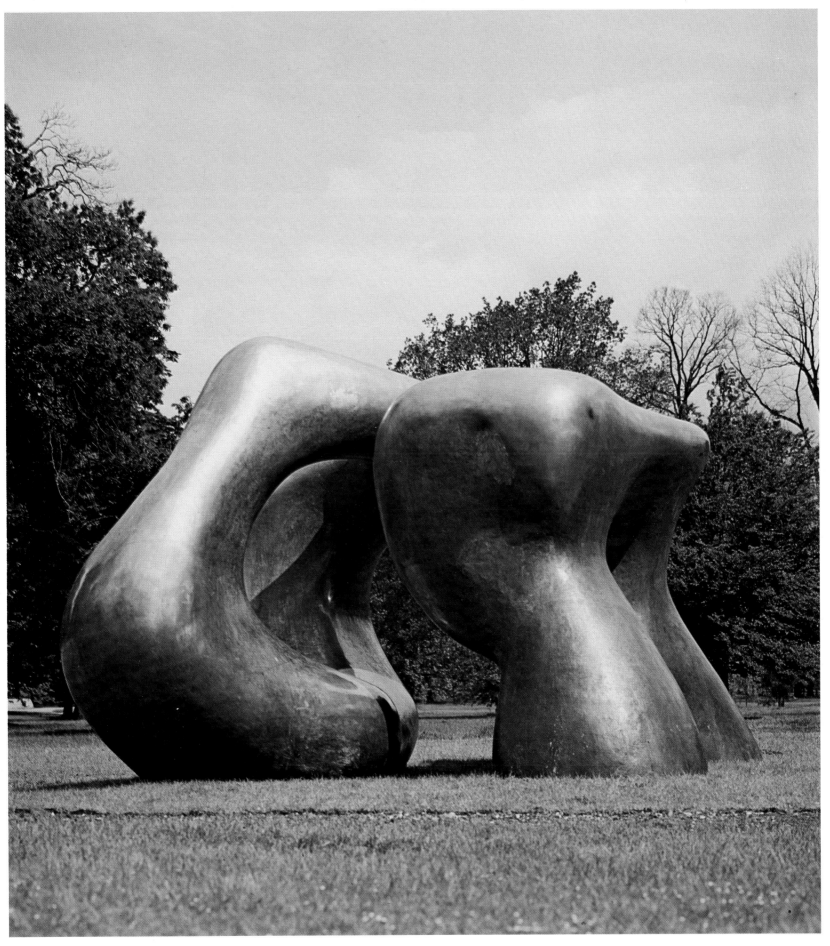

55 LARGE TWO FORMS, 1966/69, Arts Council Exhibition 1978, Kensington Gardens, London, England

56 DOUBLE OVAL, 1966, Purchase, New York, USA

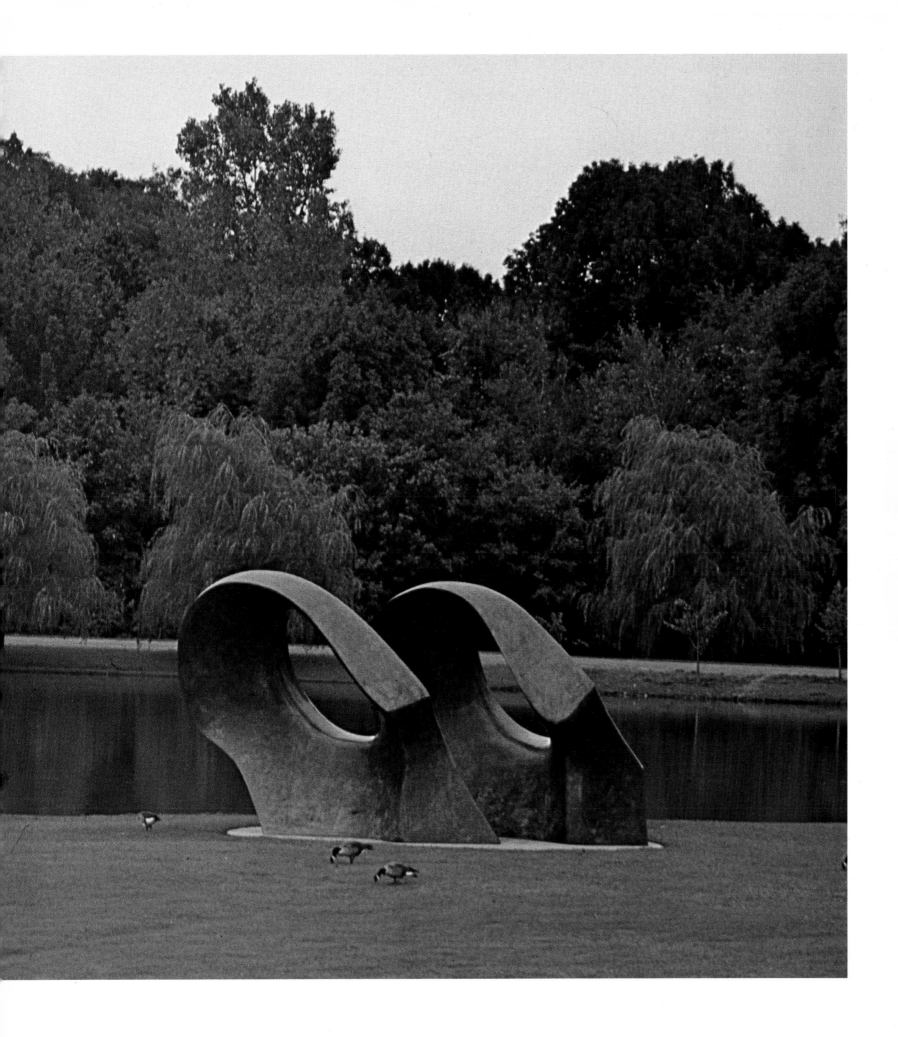

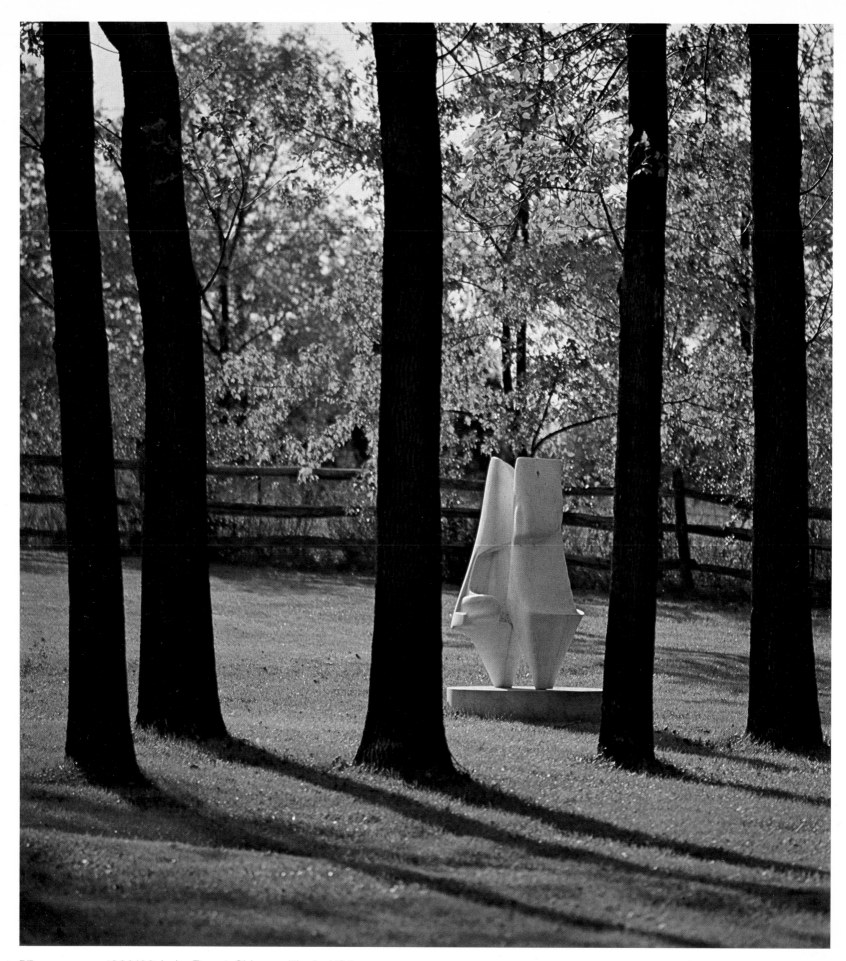

57 TWO NUNS, 1966/68, Lake Forest, Chicago, Illinois, USA

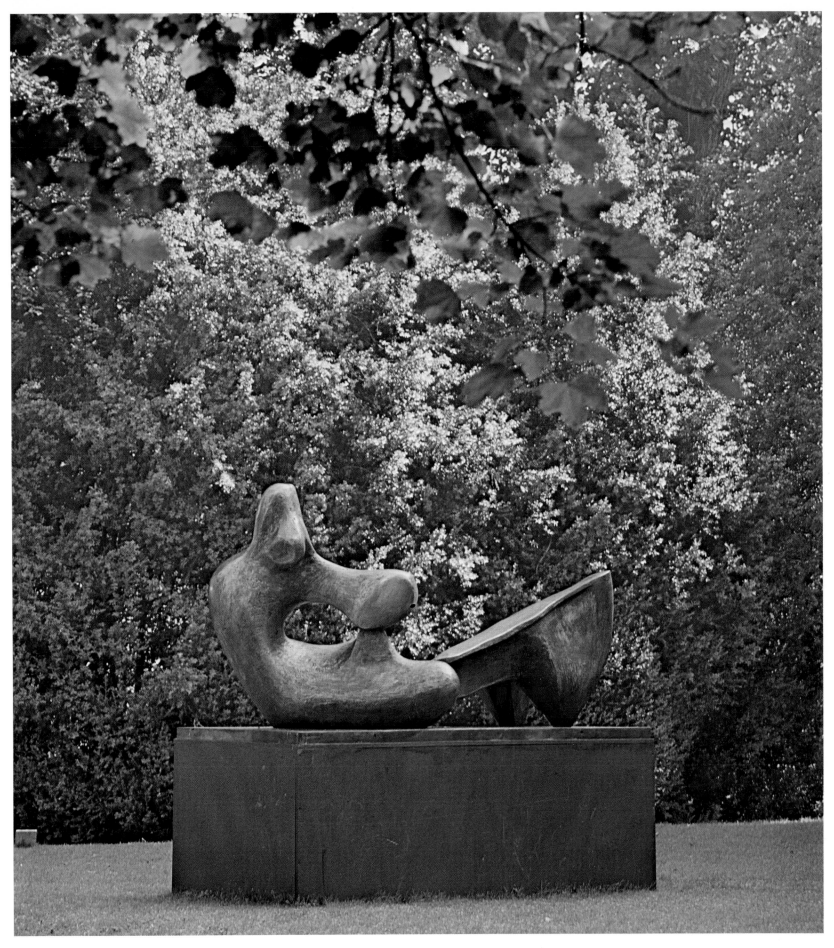

58 TWO PIECE RECLINING FIGURE NO. 9, 1968, Bregenz Exhibition 1977, Austria

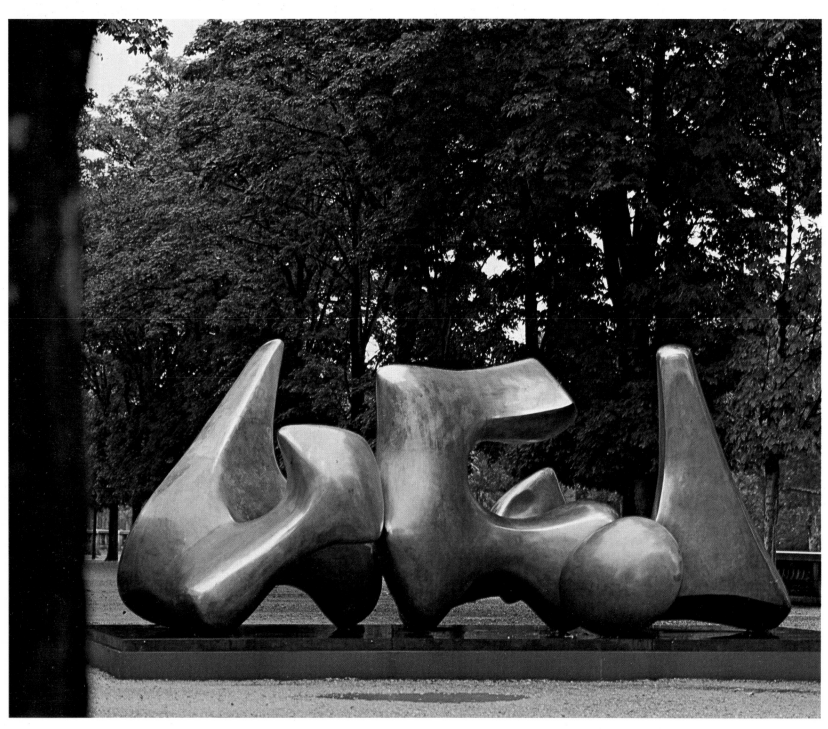

59 THREE PIECE SCULPTURE VERTEBRAE, 1968/69, Paris Exhibition 1977, France

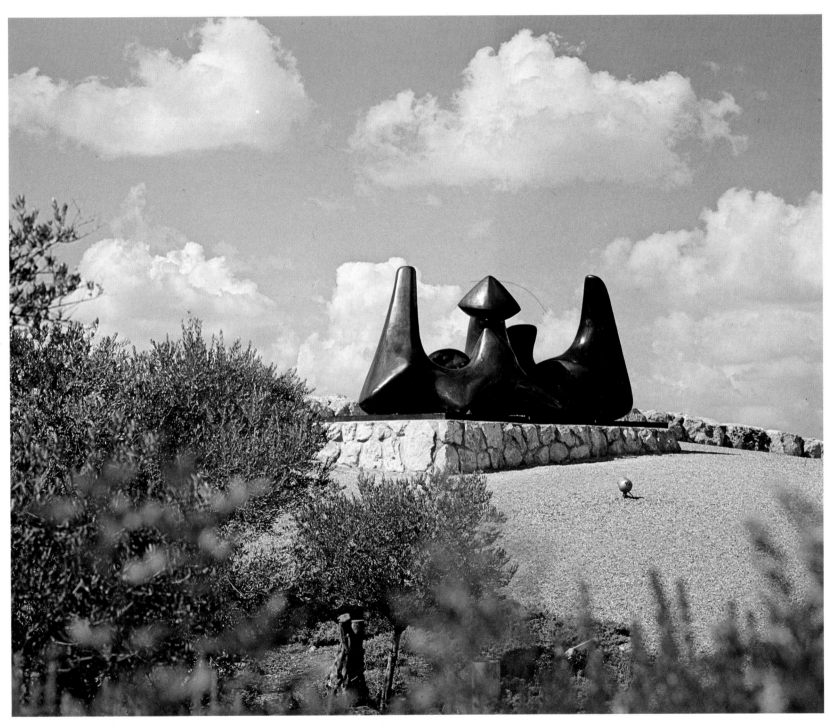

60 THREE PIECE SCULPTURE VERTEBRAE, 1968/69, Jerusalem, Israel

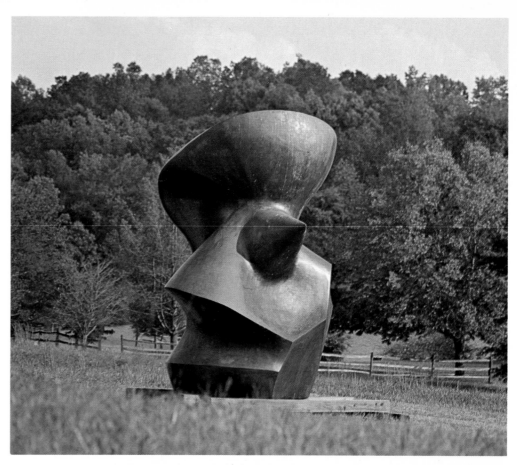

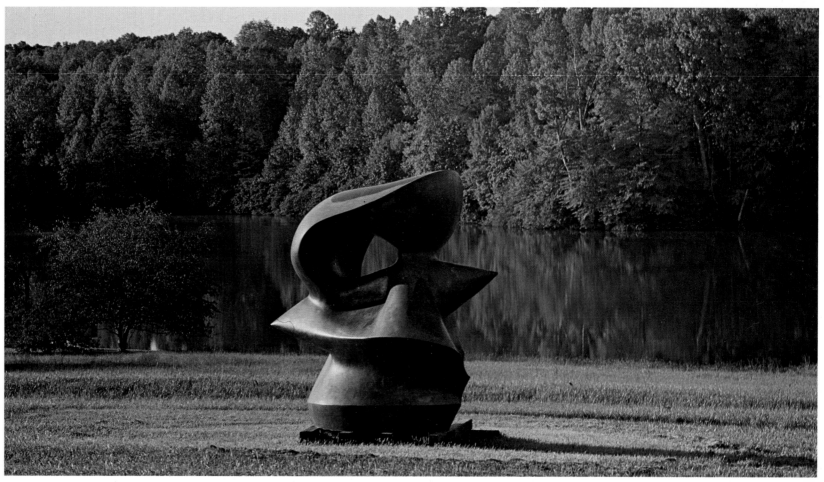

62 LARGE SPINDLE PIECE, 1968/74, Winston Salem, North Carolina, USA

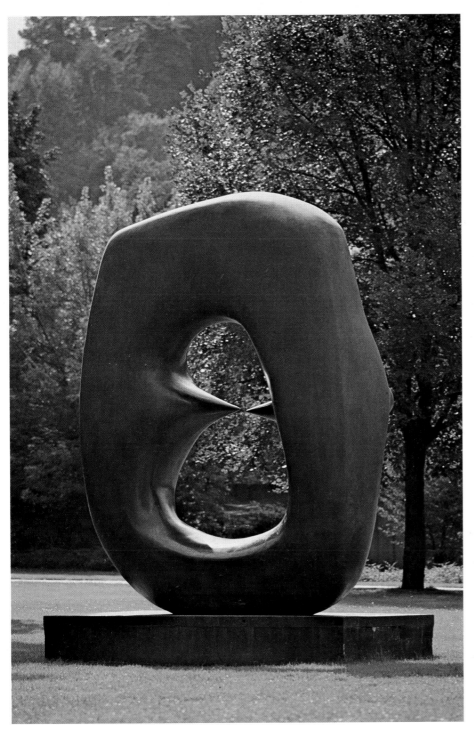

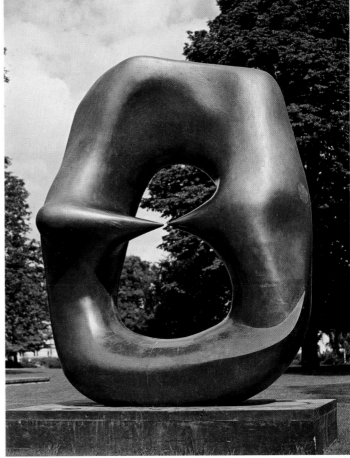

63 OVAL WITH POINTS, 1968/70, Bielefeld, West Germany

64 OVAL WITH POINTS, 1968/70

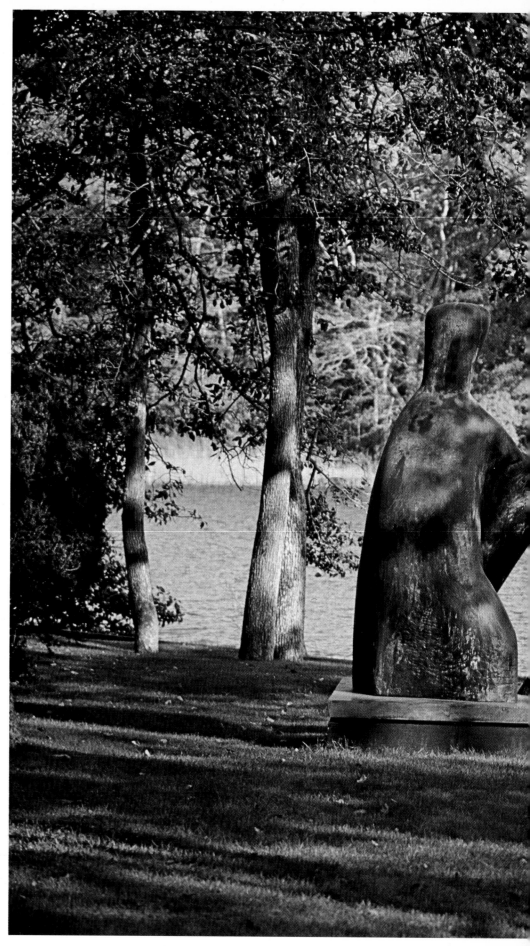

65 RECLINING FIGURE: ARCH LEG, 1969/70, East Hampton, Connecticut, USA

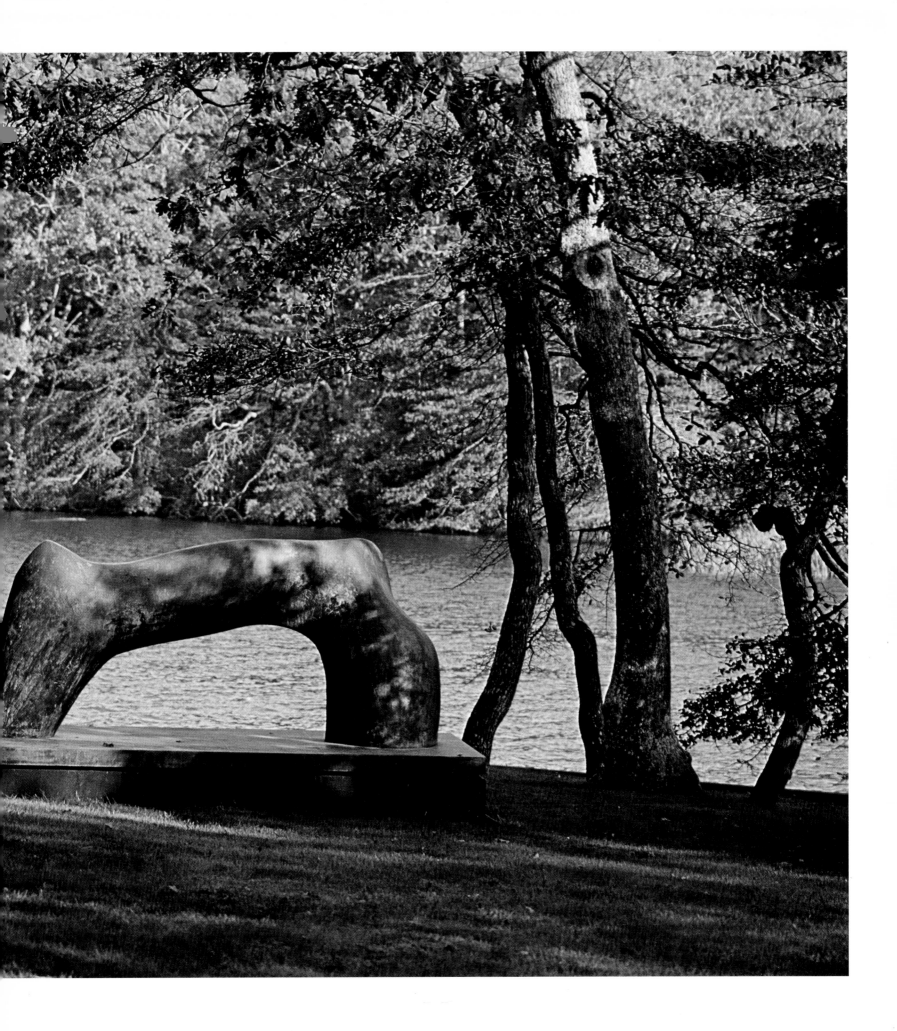

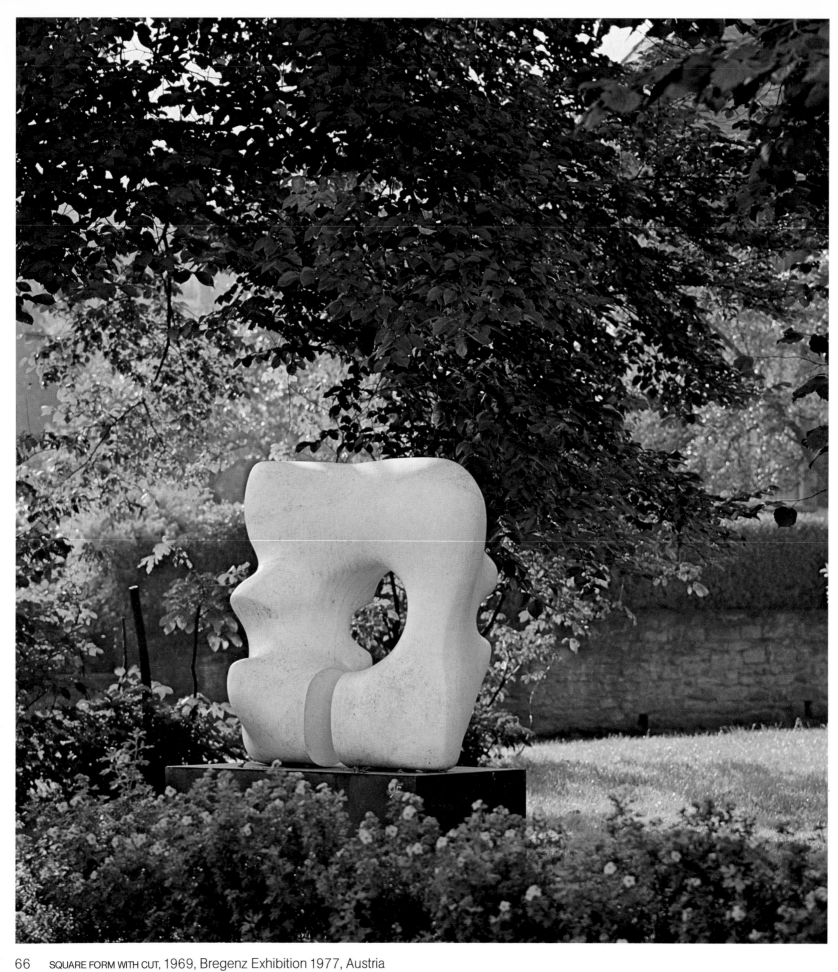

66 SQUARE FORM WITH CUT, 1969, Bregenz Exhibition 1977, Austria

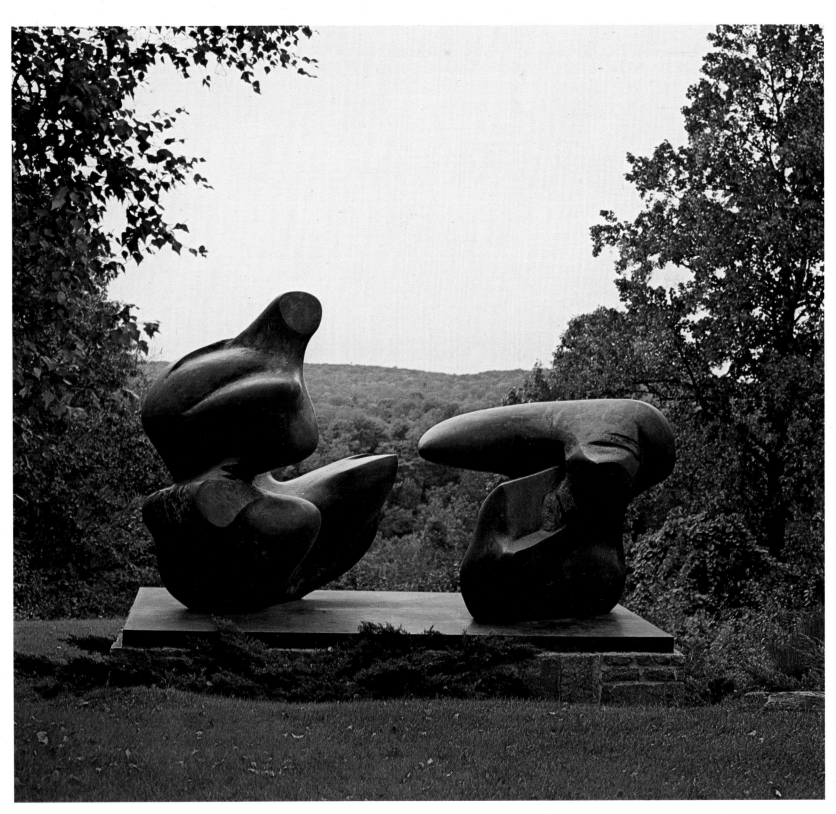

67 TWO PIECE RECLINING FIGURE POINTS, 1969/70, Greenwich, Connecticut, USA

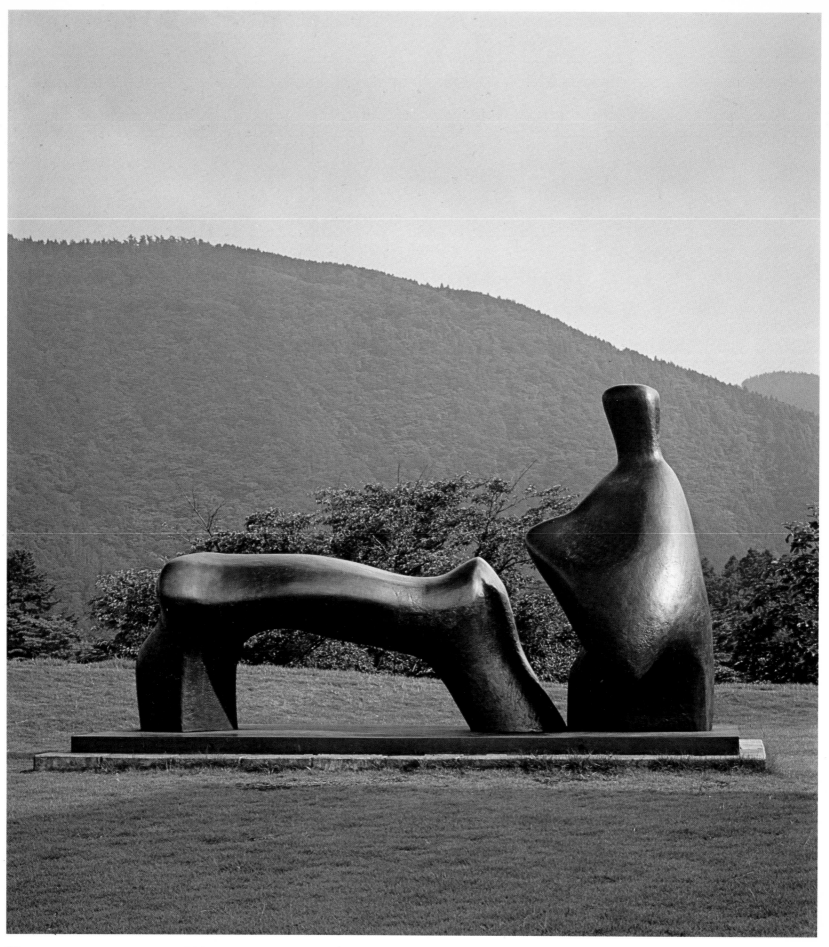

68 RECLINING FIGURE: ARCH LEG, 1969/70, Hakone, Japan

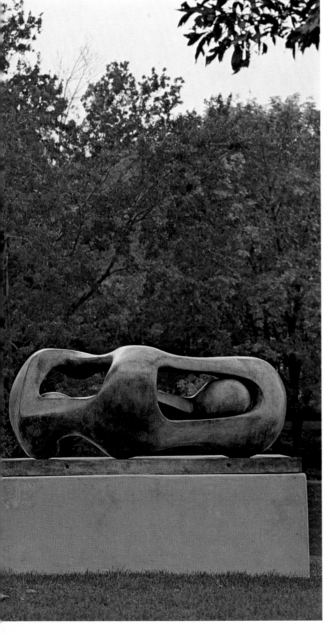

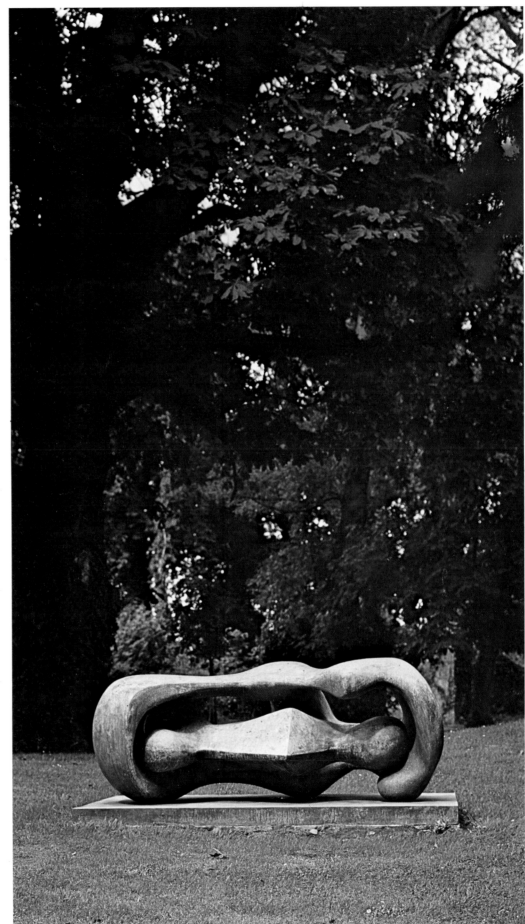

69 RECLINING CONNECTED FORMS, 1969,
Mountainville, New York, USA

70 RECLINING CONNECTED FORMS, 1969, Colwinston, Glamorgan, Wales

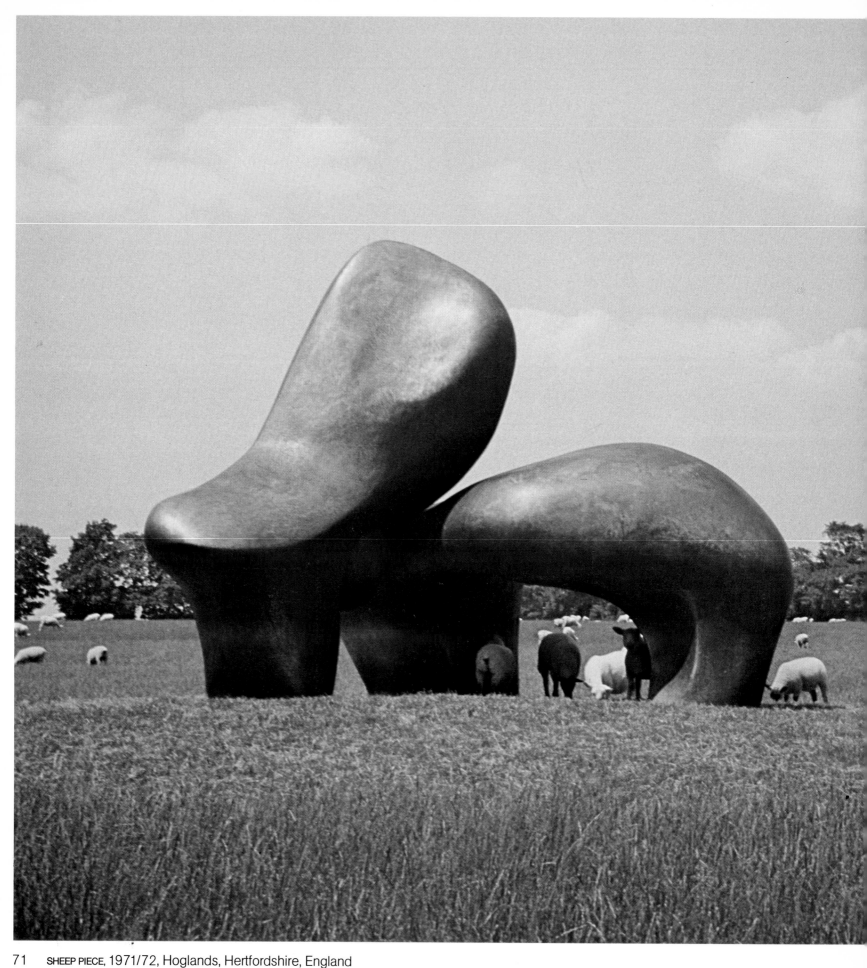

71 SHEEP PIECE, 1971/72, Hoglands, Hertfordshire, England

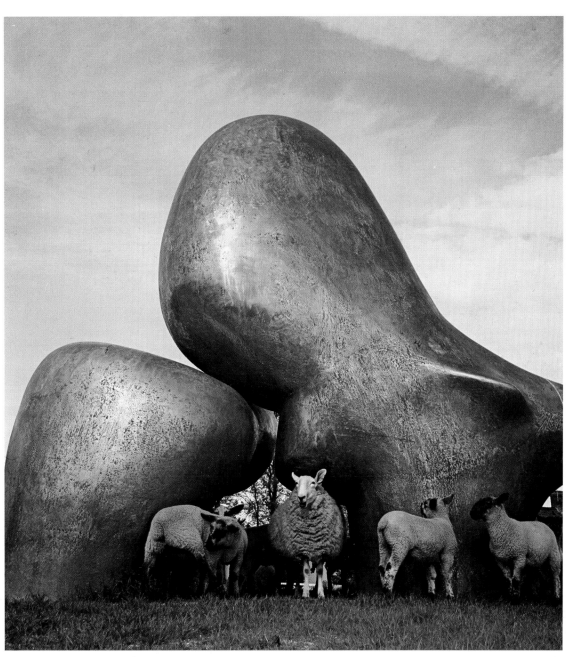

72 SHEEP PIECE, 1971/72

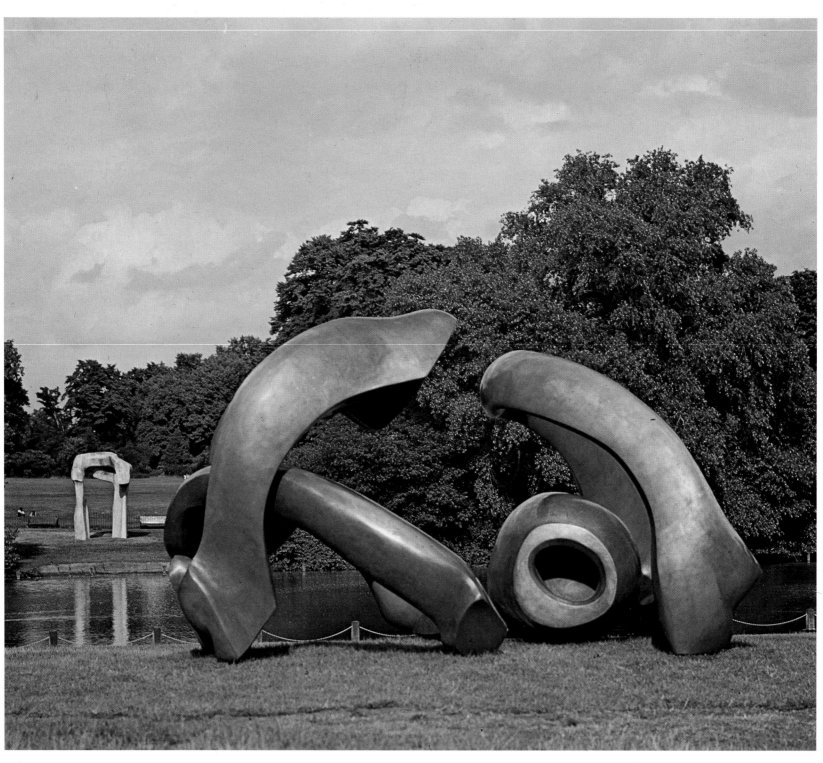

73 HILL ARCHES, 1973, Arts Council Exhibition 1978, Kensington Gardens, London, England

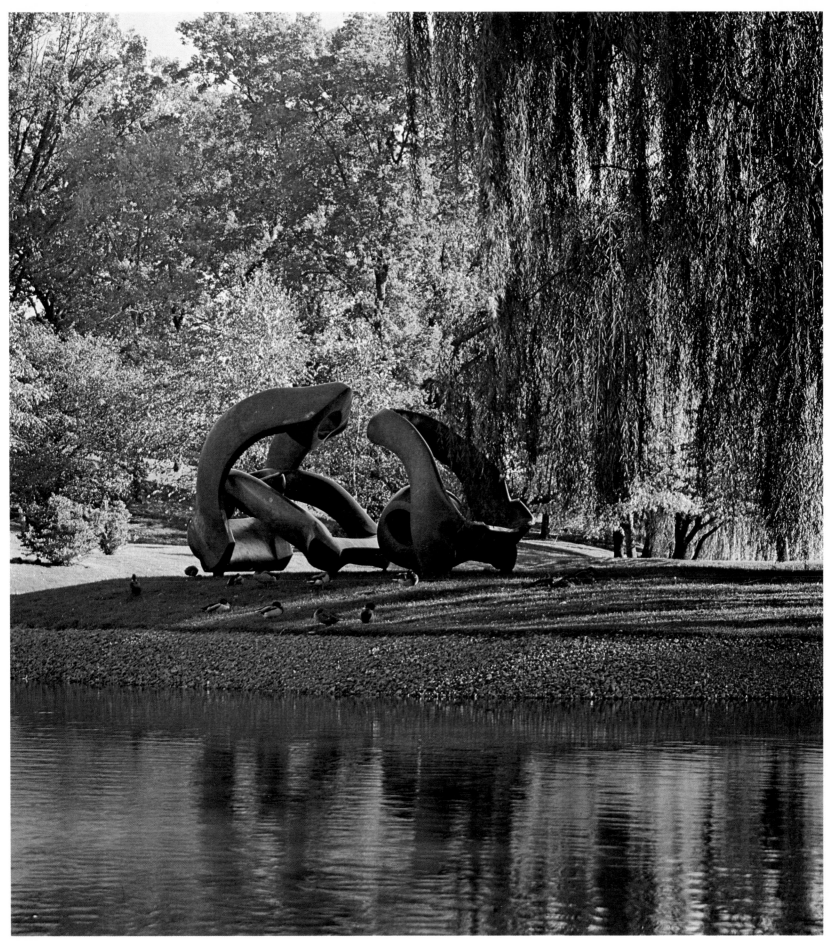

74 HILL ARCHES, 1973, Moline, Illinois, USA

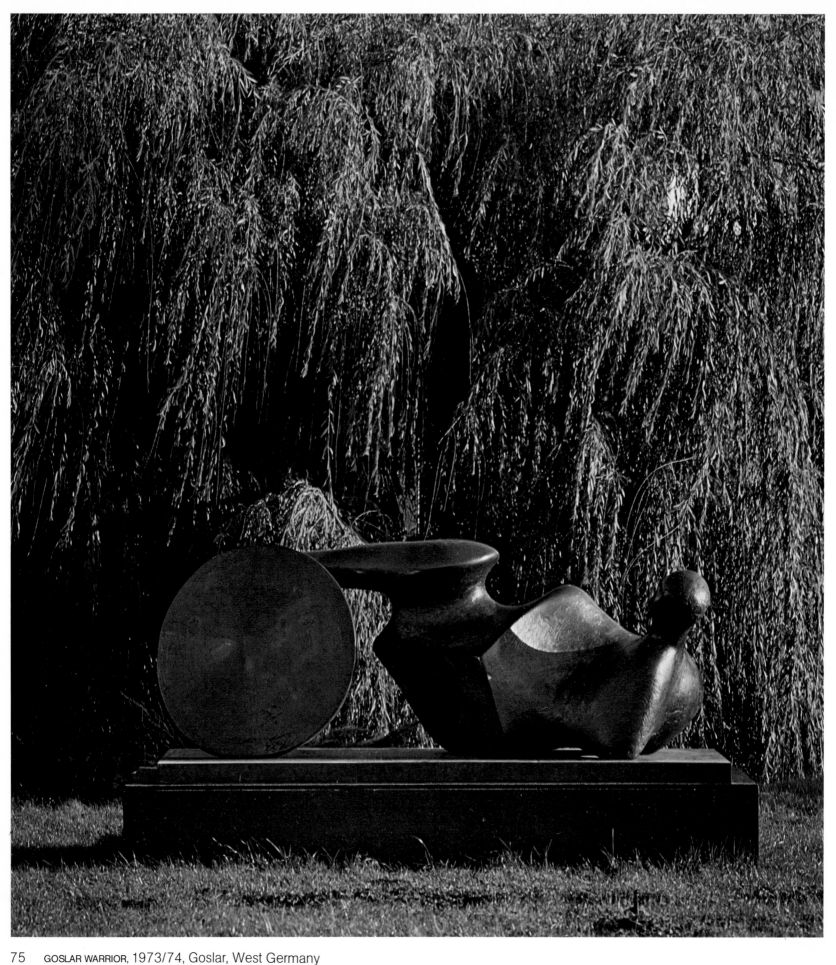

75 GOSLAR WARRIOR, 1973/74, Goslar, West Germany

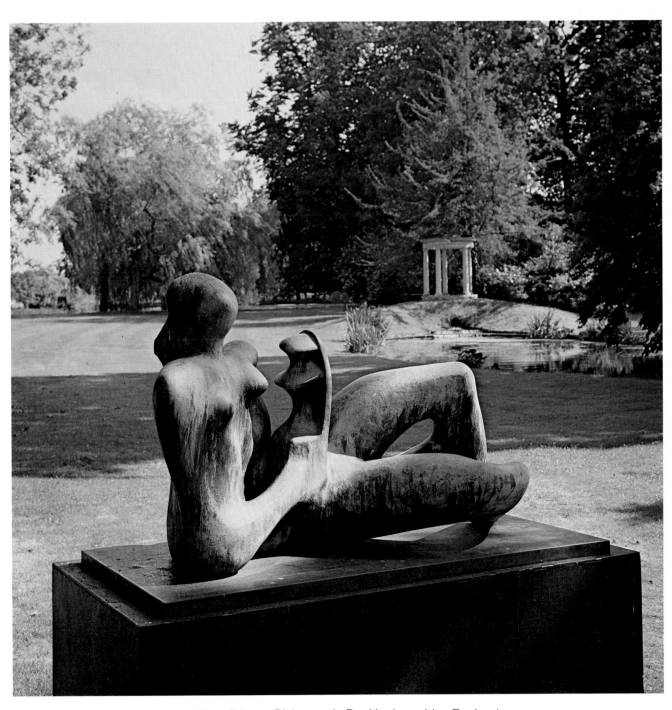

76 RECLINING MOTHER AND CHILD, 1975, Princes Risborough, Buckinghamshire, England

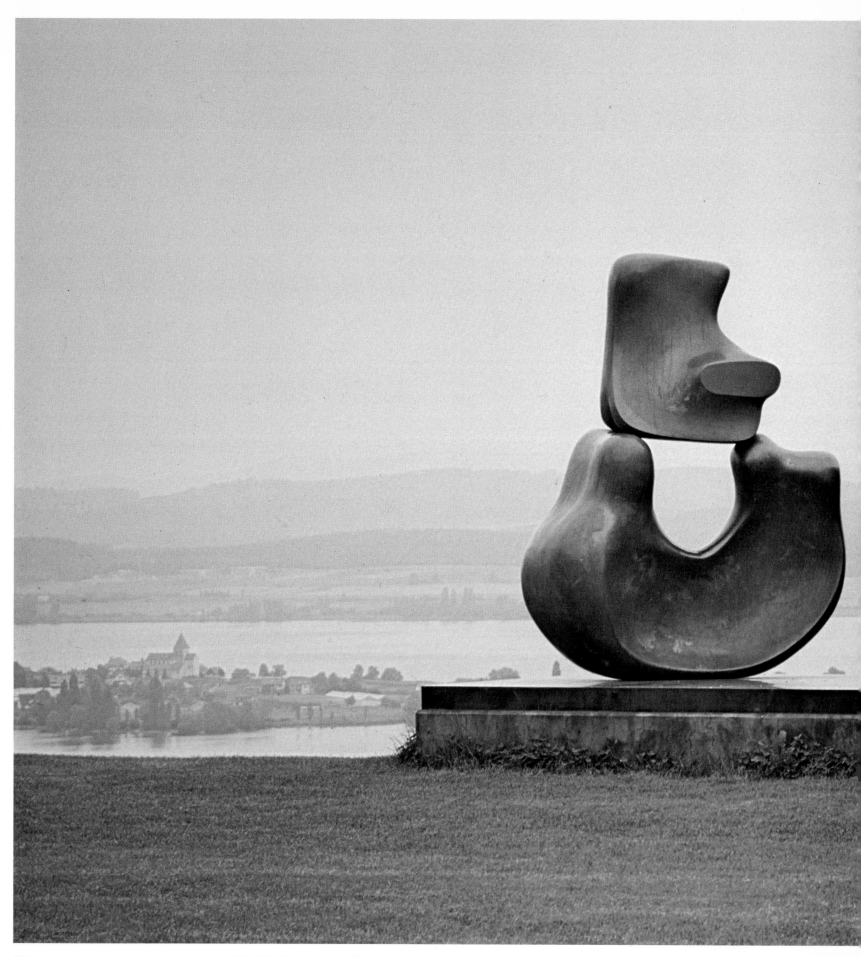

77 LARGE FOUR PIECE RECLINING FIGURE, 1972/73, Ermatingen, Thurgau, Switzerland

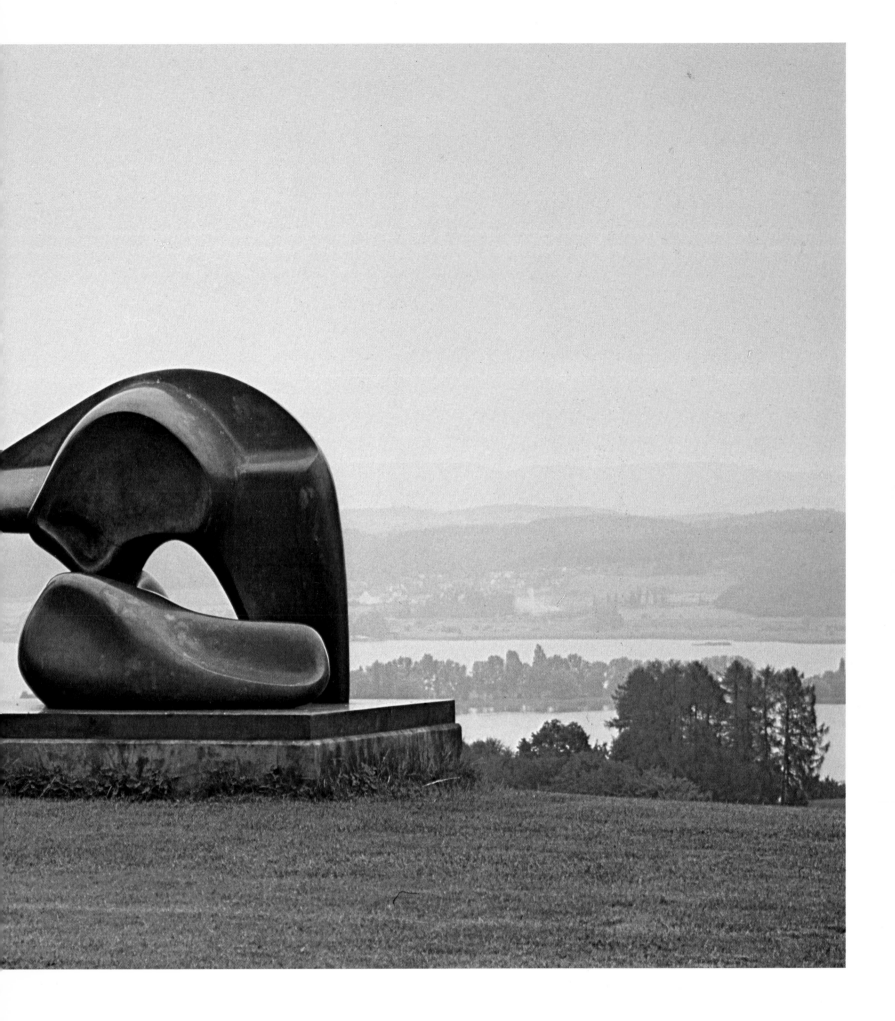

WORKING MODEL FOR THREE PIECE RECLINING FIGURE: DRAPED, 1975,
Freiaparken, Oslo, Norway

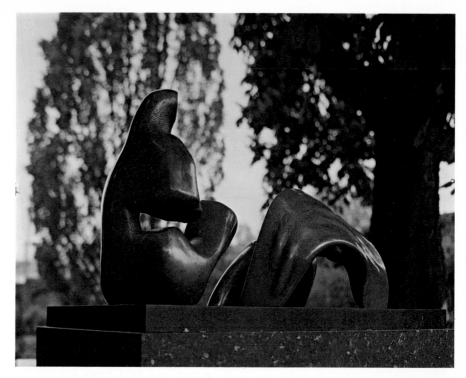

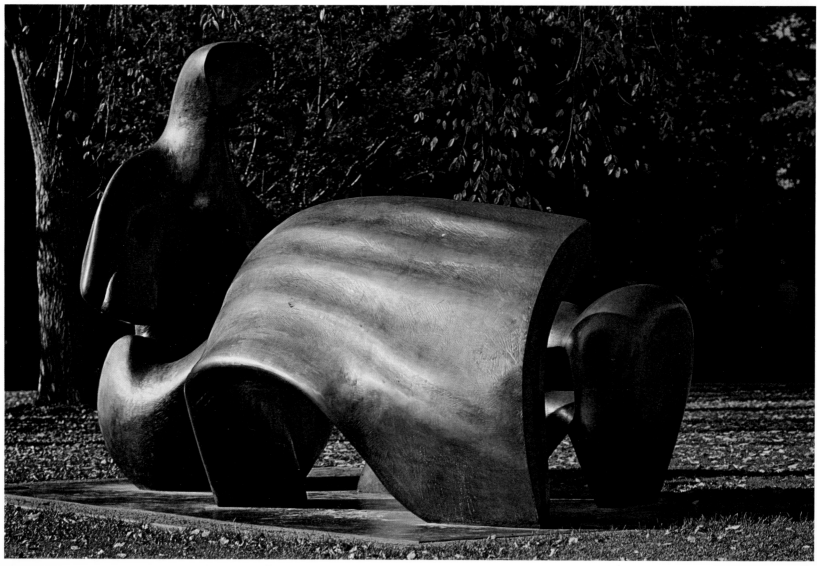

79 THREE PIECE RECLINING FIGURE: DRAPED, 1975, Cambridge, Massachusetts, USA

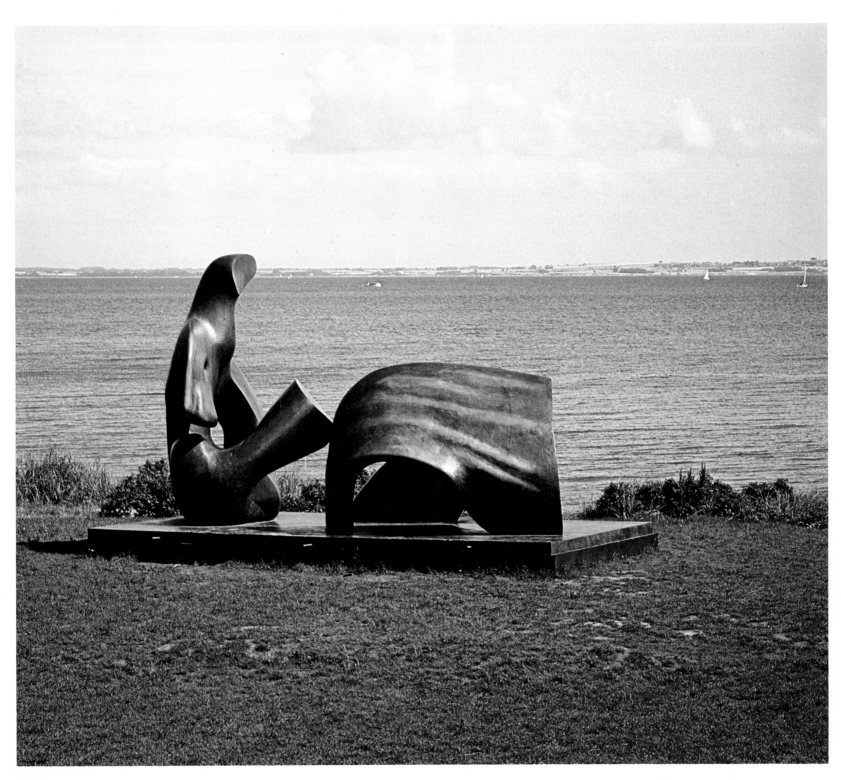

80 THREE PIECE RECLINING FIGURE: DRAPED, 1975, Humlebæk, Denmark

DETAILS OF ILLUSTRATIONS

PLATE NO.	TITLE AND YEAR	SIZE Length or height in cm.	OWNER & LOCATION	MEDIUM & EDITION
1	MEMORIAL FIGURE 1945/46	L. 142	Dartington Hall Trust, Totnes, Devon, England	Hornton Stone
2	MEMORIAL FIGURE 1945/46	L. 142	Dartington Hall Trust, Totnes, Devon, England	Hornton Stone
3	THREE STANDING FIGURES 1947/48	H. 213	Battersea Park, London England	Darley Dale Stone
4	THREE STANDING FIGURES 1947/48	H. 213	Battersea Park, London England	Darley Dale Stone
5	FAMILY GROUP 1948/49	H. 152	Hoglands, Much Hadham, Hertfordshire, England	Bronze edition of 4
6	STANDING FIGURE 1950	H. 223	Sir William Keswick, Shawhead, Dumfries and Galloway, Scotland	Bronze edition of 4
7	RECLINING FIGURE 1951	L. 229	Scottish National Gallery of Modern Art, Edinburgh, Scotland	Bronze edition of 5
8	DRAPED RECLINING FIGURE 1952/53	L. 157	Hoglands, Much Hadham, Hertfordshire, England	Cast Concrete
9	KING AND QUEEN 1952/53	H. 164	Sir William Keswick, Shawhead, Dumfries and Galloway, Scotland	Bronze edition of 5
10	KING AND QUEEN 1952/53	H. 164	Sir William Keswick, Shawhead, Dumfries and Galloway, Scotland	Bronze edition of 5

PLATE NO.	TITLE AND YEAR	SIZE Length or height in cm.	OWNER & LOCATION	MEDIUM & EDITION
11	KING AND QUEEN 1952/53	H. 164	Sir William Keswick, Shawhead, Dumfries and Galloway, Scotland	Bronze edition of 5
12	UPRIGHT MOTIVE NO. 1: GLENKILN CROSS 1955/56	H. 335	Sir William Keswick, Shawhead, Dumfries and Galloway, Scotland	Bronze edition of 6
13	UPRIGHT MOTIVE NO. 1: GLENKILN CROSS 1955/56	H. 335	Sir William Keswick, Shawhead, Dumfries and Galloway, Scotland	Bronze edition of 6
14	UPRIGHT MOTIVE NO. 1: GLENKILN CROSS 1955/56	H. 335	Sir William Keswick, Shawhead, Dumfries and Galloway, Scotland	Bronze edition of 6
15	ANIMAL HEAD 1956	L. 56	Rijksmuseum Kröller-Müller, Otterlo, Holland	Bronze edition of 10
16	RECLINING FIGURE 1956	L. 244	Pepsico Inc. Purchase, New York, U.S.A.	Bronze edition of 8
17	FALLING WARRIOR 1956/57	L. 147	Doctor Walter Hussey, Chichester, Sussex, England	Bronze edition of 10
18	FALLING WARRIOR 1956/57	L. 147	Doctor Walter Hussey, Chichester, Sussex, England	Bronze edition of 10
19	DRAPED SEATED WOMAN 1957/58	H. 185	The Hebrew University of Jerusalem, Israel	Bronze edition of 6
20	DRAPED SEATED WOMAN 1957/58	H. 185	The Hebrew University of Jerusalem, Israel	Bronze edition of 6

PLATE NO.	TITLE AND YEAR	SIZE Length or height in cm.	OWNER & LOCATION	MEDIUM & EDITION
21	DRAPED RECLINING WOMAN 1957/58	L. 208	Dr. W. Staehelin, Feldmeilen, Switzerland	Bronze edition of 6
22	DRAPED RECLINING WOMAN 1957/58	L. 208	Dr. W. Staehelin, Feldmeilen, Switzerland	Bronze edition of 6
23	SEATED WOMAN 1957	H. 145	Mr. W. R. Servaes, Orford, Suffolk, England	Bronze edition of 6
24	SEATED WOMAN 1957	H. 145	Mr. W. R. Servaes, Orford, Suffolk, England	Bronze edition of 6
25	WOMAN 1957/58	H. 152	Bregenz Exhibition 1977, Austria	Bronze edition of 8
26	WOMAN 1957/58	H. 152	Bregenz Exhibition 1977, Austria	Bronze edition of 8
27	TWO PIECE RECLINING FIGURE NO. 1 1959	L. 193	Mr. Maurice Ash, Ashprington, Devon, England	Bronze edition of 6
28	TWO PIECE RECLINING FIGURE NO. 1 1959	L. 193	Sir William Keswick, Shawhead, Dumfries and Galloway, Scotland	Bronze edition of 6
29	TWO PIECE RECLINING FIGURE NO. 2 1960	L. 259	Rijksmuseum Kröller-Müller, Otterlo, Holland	Bronze edition of 7
30	SEATED WOMAN – THIN NECK 1961	H. 163	Mr. Gordon Bunshaft, East Hampton, Connecticut U.S.A.	Bronze edition of 7

PLATE NO.	TITLE AND YEAR	SIZE Length or height in cm.	OWNER & LOCATION	MEDIUM & EDITION
31	TWO PIECE RECLINING FIGURE NO. 3 1961	L. 239	Slottsskogen Park, Gothenburg, Sweden	Bronze edition of 7
32	RECLINING MOTHER AND CHILD 1960/61	L. 220	Mr. & Mrs. Albert List, Byram, Connecticut, U.S.A.	Bronze edition of 7
33	STANDING FIGURE KNIFE EDGE 1961	H. 284	St. Stephen's Green Park, Dublin, Ireland	Bronze edition of 7
34	LARGE STANDING FIGURE KNIFE EDGE 1961/76	H. 358	Sonja Henie – Niels Onstads Foundations, Høvikodden, Oslo, Norway	Bronze edition of 6
35	LARGE STANDING FIGURE KNIFE EDGE 1961/76	H. 358	Paris Exhibition 1977, France	Bronze edition of 6
36	THREE PIECE RECLINING FIGURE NO. 1 1961/62	L. 287	Bradford Exhibition 1978, West Yorkshire, England	Bronze edition of 7
37	THE ARCH 1963/69	H. 610	Arts Council Exhitibion 1978, Kensington Gardens, London, England	Fibreglass unique
38	THE ARCH 1963/69	H. 610	Hoglands, Much Hadham, Hertfordshire, England	Fibreglass unique
39	THE ARCH 1963/69	H. 610	Hoglands, Much Hadham, Hertfordshire, England	Fibreglass unique
40	WORKING MODEL FOR LOCKING PIECE 1962	H. 107	Pepsico Inc., Purchase, New York, USA	Bronze edition of 9

PLATE NO.	TITLE AND YEAR	SIZE Length or height in cm.	OWNER & LOCATION	MEDIUM & EDITION
41	LOCKING PIECE 1963/64	H. 293	Hoglands, Much Hadham, Hertfordshire, England	Fibreglass unique
42	LOCKING PIECE 1963/64	H. 293	Hoglands, Much Hadham, Hertfordshire, England	Fibreglass unique
43	KNIFE EDGE TWO PIECE 1962/65	L. 366	Paris Exhibition 1977, France	Bronze edition of 3
44	KNIFE EDGE TWO PIECE 1962/65	L. 366	Bradford Exhibition 1978, West Yorkshire, England	Bronze edition of 3
45	WORKING MODEL FOR RECLINING FIGURE (LINCOLN CENTER) 1963/65	L. 427	Hoglands, Much Hadham, Hertfordshire, England	Bronze edition of 2
46	TWO PIECE RECLINING FIGURE NO. 5 1963/64	L. 373	on loan to The Maltings Concert Hall, Aldeburgh, Suffolk, England	Bronze edition of 3
47	TWO PIECE RECLINING FIGURE NO. 5 1963/64	L. 373	Louisiana Museum of Modern Art, Humlebæk, Denmark	Bronze edition of 3
48	ATOM PIECE 1964/65	H. 119	Mrs. Robert Levi, Lutherville, Maryland, U.S.A.	Bronze edition of 6
49	THREE WAY PIECE NO. 1 POINTS 1964/65	H. 193	Mr. & Mrs. Leigh Block, Lake Forest, Chicago, Illinois, U.S.A.	Bronze edition of 3
50	THREE WAY PIECE NO. 2 (THE) ARCHER 1964/65	H. 325	Hoglands, Much Hadham, Hertfordshire, England	Bronze edition of 2

PLATE NO.	TITLE AND YEAR	SIZE Length or height in cm.	OWNER & LOCATION	MEDIUM & EDITION
51	THREE RINGS 1966	L. 269	Mrs. Robert Levi, Lutherville, Maryland, U.S.A.	Red Travertine Marble
52	TWO FORMS 1966	L. 152	Dr. W. Staehelin, Feldmeilen, Switzerland	Red Travertine Marble
53	LARGE TWO FORMS 1966/69	L. 610	Florence Exhibition 1972, Italy	Fibreglass unique
54	LARGE TWO FORMS 1966/69	L. 610	Paris Exhibition 1977, France	Fibreglass unique
55	LARGE TWO FORMS 1966/69	L. 610	Arts Council Exhibition 1978, Kensington Gardens, London, England	Bronze edition of 4
56	DOUBLE OVAL 1966	L. 549	Pepsico Inc. Purchase, New York, U.S.A.	Bronze edition of 2
57	TWO NUNS 1966/68	H. 152	Mr. & Mrs. Leigh Block, Lake Forest, Chicago, Illinois, U.S.A.	White Marble
58	TWO PIECE RECLINING FIGURE NO. 9 1968	L. 249	Bregenz Exhibition 1977, Austria	Bronze edition of 7
59	THREE PIECE SCULPTURE VERTEBRAE 1968/69	L. 747	Paris Exhibition 1977, France	Bronze edition of 3
60	THREE PIECE SCULPTURE VERTEBRAE 1968/69	L. 747	The Israel Museum, Jerusalem, Israel	Bronze edition of 3

PLATE NO.	TITLE AND YEAR	SIZE Length or height in cm.	OWNER & LOCATION	MEDIUM & EDITION
61	LARGE SPINDLE PIECE 1968/74	H. 335	Mr. Gordon Hanes, Winston Salem, North Carolina, U.S.A.	Bronze edition of 6
62	LARGE SPINDLE PIECE 1968/74	H. 335	Mr. Gordon Hanes, Winston Salem, North Carolina, U.S.A.	Bronze edition of 6
63	OVAL WITH POINTS 1968/70	H. 331	Kunsthalle Garden, Bielefeld, West Germany	Bronze edition of 6
64	OVAL WITH POINTS 1968/70	H. 331	Kunsthalle Garden, Bielefeld, West Germany	Bronze edition of 6
65	RECLINING FIGURE: ARCH LEG 1969/70	L. 442	Mr. Gordon Bunshaft, East Hampton, Connecticut, U.S.A.	Bronze edition of 6
66	SQUARE FORM WITH CUT 1969	L. 140	Bregenz Exhibition 1977, Austria	Fibreglass unique
67	TWO PIECE RECLINING FIGURE POINTS 1969/70	L. 366	Mr. Charles Zadok, Greenwich, Connecticut, U.S.A.	Bronze edition of 7
68	RECLINING FIGURE: ARCH LEG 1969/70	L. 442	The Woods of Sculpture, Hakone, Japan	Bronze edition of 6
69	RECLINING CONNECTED FORMS 1969	L. 213	Storm King Art Center, Mountainville, New York, U.S.A.	Bronze edition of 9
70	RECLINING CONNECTED FORMS 1969	L. 213	Mr. Matthew Pritchard, Colwinston, Glamorgan, Wales	Bronze edition of 9

PLATE NO.	TITLE AND YEAR	SIZE Length or height in cm.	OWNER & LOCATION	MEDIUM & EDITION
71	SHEEP PIECE 1971/72	H. 549	Hoglands, Much Hadham, Hertfordshire, England	Bronze edition of 3
72	SHEEP PIECE 1971/72	H. 549	Hoglands, Much Hadham, Hertfordshire, England	Bronze edition of 3
73	HILL ARCHES 1973	L. 549	Arts Council Exhibition 1978, Kensington Gardens, London England	Bronze edition of 3
74	HILL ARCHES 1973	L. 549	Deere & Company, Moline, Illinois, U.S.A.	Bronze edition of 3
75	GOSLAR WARRIOR 1973/74	L. 249	Goslar, West Germany	Bronze edition of 7
76	RECLINING MOTHER AND CHILD 1975	L. 213	Mr. James Gourlay, Princes Risborough, Buckinghamshire, England	Bronze edition of 7
77	LARGE FOUR PIECE RECLINING FIGURE 1972/73	L. 403	The Union Bank of Switzerland, Ermatingen, Thurgau, Switzerland	Bronze edition of 7
78	WORKING MODEL FOR THREE PIECE RECLINING FIGURE: DRAPED 1975	L. 115	Aksjeselskapet Freia, Freiaparken, Oslo, Norway	Bronze edition of 9
79	THREE PIECE RECLINING FIGURE: DRAPED 1975	L. 442	Massachusetts Institute of Technology, Cambridge, Massachusetts, U.S.A.	Bronze edition of 6
80	THREE PIECE RECLINING FIGURE: DRAPED 1975	L. 442	Louisiana Museum of Modern Art, Humlebæk, Denmark	Bronze edition of 6

BIOGRAPHY

MOORE, Henry, OM 1963; CH 1955; FBA 1966; Hon. FRIBA 1971.
Born in Castleford, Yorkshire 30 July 1898. Son of
Raymond Spencer Moore and Mary Baker. Married in 1929
to Irene Radetzky.

Educated at Castleford Grammar School. After serving
European War 1917–19 in Army studied at Leeds School of
Art and Royal College of Art.

Official War Artist 1940–42. A Trustee; Tate Gallery
1941–48 and 1949–56; National Gallery 1955–63 and
1964–74. Member; Arts Council 1963–67; Royal Fine Art
Comn. 1947–71. Formed the Henry Moore Foundation in 1977.

MAJOR EXHIBITIONS OF HIS WORK HELD IN LONDON:
1928, 1931, 1933, 1935, 1936, 1940, 1945, 1946, 1948, 1951, 1953,
1955, 1960, 1961, 1963, 1965, 1967, 1968, 1974, 1975, 1976, 1978.

MAJOR EXHIBITIONS OF HIS WORK HELD IN OTHER PLACES:
Leeds 1941
New York 1946
Chicago 1947
San Francisco 1947
Australia Tour 1947
Venice Biennale 1948 (at which he was awarded First
Prize for Sculpture)
Europe Tour 1949/51
Cape Town 1951
Scandinavia Tour 1952/53
Rotterdam 1953
Antwerp 1953
Sao Paulo 1953 (at which he was awarded 1st Prize in
Foreign Sculpture)
Germany Tour 1953/54
USA Tour 1955
Basle 1955
Yugoslavia Tour 1955

Canada, New Zealand, Australia, R.S.A. Tour 1955/58
Paris 1957
Arnhem 1957
Japan Tour 1959
Spain and Portugal Tour 1959
Poland Tour 1959
Europe Tour 1960/61
Edinburgh 1961
USA Tour 1963
Latin America Tour 1964/65
USA Tour 1966/68
East Europe Tour 1966
Israel Tour 1966
Canada Tour 1967/68
Holland and Germany Tour 1968
Japan Tour 1969/70
New York 1970
Iran Tour 1971
Munich 1971
Paris 1971
Florence 1972
Luxembourg 1973
Los Angeles 1973
Toronto 1974
Scandinavia Tour 1975/76
Zurich 1976
Paris 1977

EXAMPLES OF WORK ARE IN:
The Tate Gallery
British Museum
The National Gallery, Washington
Museum of Modern Art, New York
Albright Knox Art Gallery, Buffalo
and other public galleries in:
UK

USA
Germany
Italy
Switzerland
Holland
Sweden
Denmark
Norway
France
Australia
Brazil
Israel
South Africa
Japan and others.

PUBLICATIONS:
Heads, Figures and Ideas 1958.
Henry Moore on Sculpture (with Philip James) 1966.
Catalogues Raisonne, Sculpture, four vols published
by Lund Humphries.
Graphics, two vols published by G. Cramer.
Principal monographs by Will Grohmann, John Russell,
Robert Melville, Kenneth Clark (drawings), David Finn,
John Hedgecoe, G. C. Argan, Henry Seldis, Herbert
Read.

CHRONOLOGY OF HONOURS AND APPOINTMENTS

1941 Appointed a trustee of the Tate Gallery, London (1941 to 1956)

1945 Created Honorary Doctor of Literature, Leeds University

1948 Appointed a member of the Royal Fine Art Commission, (1948 to 1971)
Elected honorary associate of the R.I.B.A.
Elected foreign corresponding member of the Academie Royal Flamande des Sciences, Lettres et Beaux-Arts de Belgique
Awarded the International Prize for sculpture XXIVth Biennale, Venice

1951 Elected foreign member of the Swedish Royal Academy of Fine Arts

1953 Created Honorary Doctor of Literature, London University
Awarded the International Prize for sculpture 2nd. Biennale, Sao Paulo

1955 Elected foreign honorary member of the American Academy of Arts and Sciences
Appointed member of the Order of the Companions of Honour
Appointed a trustee of the National Gallery, London (1955 to 1974)

1957 Awarded prize at the Carnegie International, Pittsburg
Awarded the Stefan Lochner Medal by the City of Cologne

1958 Appointed Chairman of the Auschwitz Memorial Committee
Created Honorary Doctor of Arts, Harvard University

1959 Created Honorary Doctor of Literature, Reading University
Created Honorary Doctor of Laws, Cambridge University
Awarded Gold Medal by the Society of the Friends of Art, Krakow
Awarded Foreign Ministers prize, 5th. Biennale, Tokyo
Nominated Corresponding Member Academician by the Academia Nacional de Bellas Artes, Buenos Aires

1961 Created Honorary Doctor of Literature, Oxford University
Elected member of the American Academy of Art and Letters
Elected member of the Akademie der Kunste, West Berlin

1962 Elected Honorary Fellow of Lincoln College, Oxford

Created Honorary Freeman of the Borough of Castleford
Appointed member of the National Theatre Board
Created Honorary Doctor of Engineering, Technische Hochschule, West Berlin
Created Honorary Doctor of Letters, Hull University

1963 Appointed member of the Order of Merit
Awarded the Antonio Feltrinelli Prize for sculpture by the Accademia Nazionale dei Lincei, Rome
Appointed member of the Arts Council of Great Britain (1963 to 1964)
Elected Honorary Member of the Society of Finnish Artists

1964 Awarded Fine Arts Medal by the Institute of Architects, U.S.A.

1965 Elected Honorary Fellow of Churchill College, Cambridge
Created Honorary Doctor of Letters, Sussex University

1966 Elected Fellow of the British Academy
Created Honorary Doctor of Laws, Sheffield University
Created Honorary Doctor of Literature, York University
Created Honorary Doctor of Arts, Yale University

1967 Created Honorary Doctor of Laws, St. Andrews University
Created Honorary Doctor, Royal College of Art, London
Created Honorary Professor of Sculpture, Carrara Academy of Fine Art

1968 Awarded the Erasmus Prize, The Netherlands
Awarded the Einstein Prize by the Yeshiva University, New York
Awarded the Order of Merit by the Federal German Republic
Created Honorary Doctor of Laws, Toronto University, Canada.

1969 Created Honorary Doctor of Laws, Manchester University
Created Honorary Doctor of Letters, Warwick University
Created Honorary member of the Weiner Secession, Vienna

1970 Created Honorary Doctor of Literature, Durham University

1971 Created Honorary Doctor of Letters, Leicester University
Elected Honorary Fellow of the R.I.B.A., Royal Institute of British Achitects
Created Honorary Doctor of Letters, York University, Toronto

1972 Awarded Medal of the Royal Canadian Academy of Arts

Created Cavaliere di Gran Croce dell'Ordine al Merito della Republica Italiana

Awarded the Premio Internazionale 'Le Muse', Florence

Awarded the Premio Ibico Reggino Arti Figurative per la Scultura, Reggio Calabria

Created Foreign member of the Orden pour le Merite für Wissenschaffen und Kunste, West Germany

1973 Awarded the Premio Umberto Biancamano, Milan

Created Commandeur de l'Ordre des Arts et des Lettres, Paris

1974 Created Honorary Doctor of Humane Letters, Columbia University, New York

Elected Honorary member of the Royal Scottish Academy of Painting, Sculpture and Architecture, Edinburgh

1975 Created Honorary member of the Akademie der Bildenden Kunste, Vienna

Elected Membre de l'Institut, Akademie des Beaux Arts, Paris

Awarded the Kaiserring der Stadt Goslar, West Germany

Created Associate of the Academie Royale des Sciences, des Lettres et des Beaux Arts de Belgique

1977 Elected member of the Serbian Academy of Sciences and Arts

1978 Awarded the Grosse Goldene Ehrenzeichen by the City of Vienna

Awarded the Austrian Medal for Science and Art

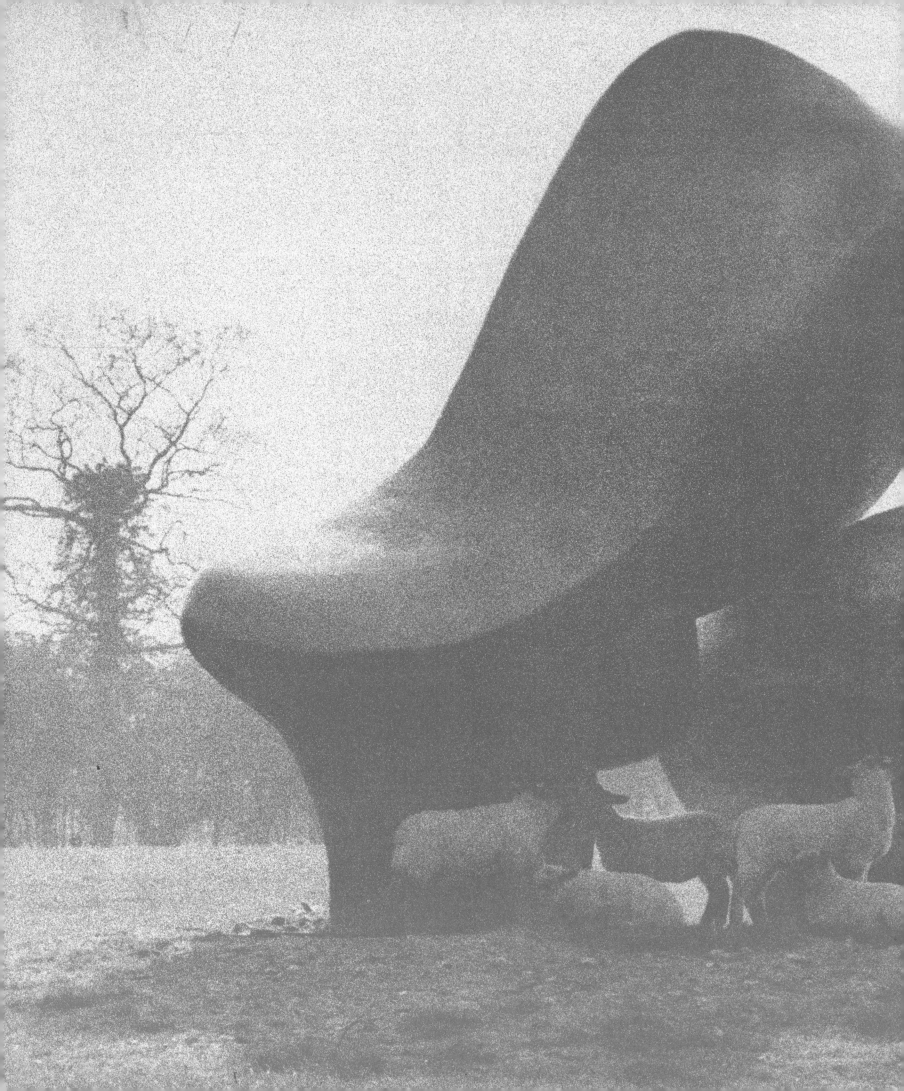